W9-ARW-386

the KODAK Workshop Series

Using Filters

Tom Beetmann

Using Filters

by the editors of Eastman Kodak Company

The easily built Harris Shutter was used to add swirls of color to this pirouetting ballerina. See page 90 for instructions on building a Harris Shutter.

the KODAK Workshop Series

Helping to expand your understanding of photography

Using Filters

Written by the editors of Eastman Kodak Company

Kodak editor: Derek Doeffinger

Book Design: Quarto Marketing Ltd.,
212 Fifth Avenue,
New York, New York 10010

Designed by Roger Pring

Cover photograph by Steven Labuzetta
Cover design by Daniel Malczewski

Equipment photography by Ray Miller and Tom Beelmann

© Eastman Kodak Company, 1981

Consumer/Professional & Finishing Markets
Eastman Kodak Company
Rochester, New York 14650

Kodak publication KW-13
CAT 143 9868
Library of Congress Catalog Card Number 81-67034
ISBN 0-87985-277-1

10-84-DE Minor Revision
Printed in the United States of America

The Kodak materials described in this book are available from those dealers normally supplying Kodak products. Other materials may be used, but equivalent results may not be obtained.

KODAK, EKTACHROME, KODACOLOR, KODACHROME,
PANATOMIC-X, PLUS-X, TRI-X, VERICHROME,
VERICOLOR, VR, and WRATTEN are trademarks.

Buck Campbell

INTRODUCTION

Filters come in a few shapes and many sizes, and produce an astounding number of effects. They can soften images, multiply them, color them, lighten them, darken them, and stretch them. The results can be obvious or subtle.

Although the effects provided by filters are many, the reasons for using them are few. When you get right down to it, there are only two reasons for using filters, and these two reasons contradict each other.

The first reason is to reproduce the tones or colors of a scene as best as possible. You want precise realism, not an artistic interpretation. You want to reproduce the subject as it was, not as you thought it should be. Color precision, tone rendition: these are the standards that must be met. These rule which, if any, filter to use.

The second reason reverses the first. You don't care how the original scene looked. You want to show it as you imagined it. You use a sepia filter

to heighten the sense of nostalgia for an abandoned roadhouse. You use a blue filter to steep a farmhouse buried under snowdrifts in the cold blue that adds a biting edge to the frigid temperatures and blowing snow. Your creativeness surges forth to romp with wild colors and relax with subtle shades.

Under the flags of realism and creativity, this book steers its course. Whichever flag you choose, your goal is the same: a better picture. Filters can help you reach that goal. To become proficient with filters you need to know how they work. We explain how they react with light to produce changes in photos and show the different types of filters. We explain which filters to use for realistic results for both color and black-and-white photographs. We also let you know when you're likely to need a filter to achieve normal colors and normal black-and-white tones.

Although using filters for realism is important, for most people, the fun is

in creative filtration. Sunsets swimming in orange, snowdrifts shivering in blue, streetlights exploding in color, these are the scenes that stir both the viewer and the photographer. We show you pictures made possible only by creative filtration, tell you how they were done, and show you how you can photograph your own. We even instruct you how to make some special-effects filters with household materials.

When you finish this book, you will know what you do and don't like about filtered pictures. You'll know how to vary a technique to customize your work. And you'll know when you may be better off without a filter than with one. We've given you a lot of pictures to study. We don't expect you to like all of them. In fact, you should reject some of them. Not because they're bad. But because they're not for you. However, we'll convert quite a few of you to creative filtering. Preview some of the pictures and see what we mean.

Contents

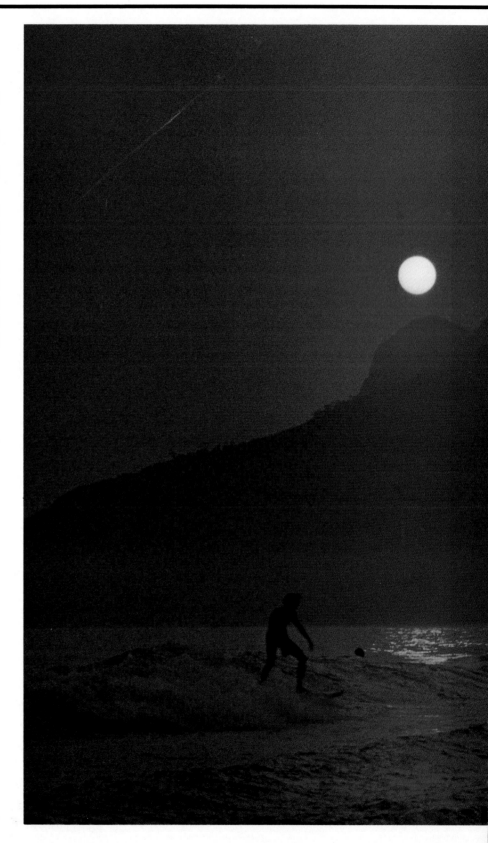

© 1981 Anthony Boccaccio

How filters work

How much can there be to know about the workings of a filter? There are no dials, no levers, no circuits, no batteries. No buttons, no cords, no readouts. A filter is a plain and simple device. It's little more than a piece of glass or gelatin that you place in front of the camera lens. So how much can there be to know? Not a lot. A little about light and a little about what a filter does to light.

A filter transmits light its own color and similar colors. Depending on the filter's density, it blocks some or most of the other colors.

WHAT A FILTER DOES

Let's begin with what a filter does to light. A filter changes the color balance of light. Both black-and-white and color pictures are made from the many colors of light reflected from the scene onto the film. Any change in the color balance of light reflected from the scene changes tones in black-and-white pictures and colors in color pictures.

Hold a red filter in front of your eye. You can clearly see the overall red cast it imparts to the scene. Use a red filter with color film and the result is obvious—a reddish picture. The result is not so obvious with black-and-white film. It can't become reddish. *So what happens?* Look again through the red filter. Look at some red, green, or blue objects. See how certain colors appear darker and others lighter when viewed through the filter? The same thing happens in black-and-white pictures, only in shades of gray. Reddish colors in the scene become a lighter gray in the print, and greenish and bluish colors become a darker grey. View the scene with and without the filter. Compare. Flick the filter back and forth across your eye to make the differences obvious.

What you see is that a filter lightens tones of objects colored similarly to the filter and darkens tones of objects colored dissimilarly. With such knowledge, you can casually use filters with black-and-white film and get good results. For a more thorough understanding of how filters work and how you can use them for both black-and-white and color pictures, you need a background on light and its relationship to color.

That a combination of colors actually makes up white light was shown by 23-year old Isaac Newton in 1666. Like many of his day, Newton must have been intrigued by the colors produced by light leaving a prism. The standard explanation of the origin of the colors was that they derived from something in the prism and not from the light. Newton, who also invented calculus and explained gravity, must have thought otherwise. He revised that explanation with complex insight and one simple act: He placed a second prism behind the first. The result? The rainbow of colors was recombined into white light. The conclusion: White light is a combination of all the colors of the spectrum.

Derek Doeffinger

On color film a filter imparts its color to the picture. The red, green, and blue filters used here impart their colors to the picture.

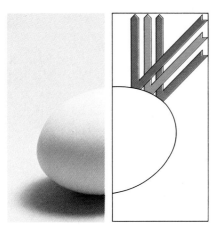

An egg appears white because it reflects all the light striking it.

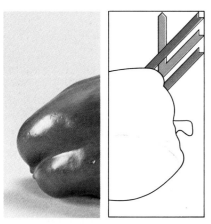

Although struck by white light, a pepper appears green because it reflects only green light.

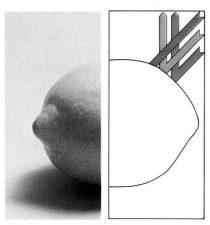

A lemon appears yellow because it reflects red and green, a combination we perceive as yellow.

LIGHT AND COLOR

Daylight is a great deceiver. With sparkling clarity, it illuminates the world and the world responds with a clamor of color. Not readily apparent is that tulips, cars, redheads, and most other objects can show color only because of light, and in this case, daylight.

The seemingly colorless daylight actually consists of all the colors of the rainbow. This complete combination of colors is why daylight appears colorless. Take away some of the colors in daylight and it might appear as colored as a theatrical spotlight or a sunset.

This colorless light is called white light. Why it's called white light is simple. Objects that reflect all of the colors combined in it appear white. If an object reflects only some of the colors in white light, that object appears colored. If an object reflects none of the colors, that object appears black.

We see only the colors reflected or transmitted if the object is transparent. We never see the colors absorbed. For example, an apple appears red because it reflects red light—it absorbs blue and green light. A pepper appears green because it reflects green light and absorbs red and blue light.

For practical purposes, we can consider white light as consisting of equal proportions of red, green, and blue light.* These are the three primary colors. In various combinations red, green, and blue can make up all other colors. A cup of red light and a dash of green light makes orange light. Although the combinations are limited, the proportions (1/5 red, 2/5 blue and 2/5 green, for example) can

*Mixing of light differs from mixing of pigments such as paint. In mixing of light, colors are additive. In mixing of paint, colors are subtractive.

When combined in equal proportions, red, green, and blue light form white light. When combined in unequal proportions, they can form all the colors of the spectrum.

be varied infinitely to give rise to every imaginable hue.

When you take away one of the primaries, say red, and combine the remaining two primaries, blue and green, you get a new color—cyan.

Three colors can be produced by alternately combining two of the three primary colors. They are **yellow** (1/2 red and 1/2 green), **cyan** (1/2 green and 1/2 blue), and **magenta** (1/2 red and 1/2 blue).

The three colors resulting from adding two primary colors are known as secondary colors. Many of the filters you will use have either one of the primary or secondary colors. By knowing what colors combine to make another color, you'll be better prepared to choose the appropriately colored filter to manipulate subjects.

FILTERING LIGHT

Like any colored object, a filter also absorbs some light. Because it is transparent, it transmits the remaining light instead of reflecting it. The color of a filter is the color of light it transmits. A red filter is red because it absorbs blue and green light and transmits red light. How much light it absorbs depends on the density of the filter.

Does a red filter transmit yellow light? No, but it does transmit some light from yellow objects. *How can that be?* Yellow actually consists of red and green. Therefore, a red filter transmits the red portion of yellow but blocks the green portion. The color circle on this page shows the relationships between colors. On this color circle, a filter transmits its own color and all or portions of its adjoining neighbors. It absorbs part or most of all others. Notice that the color circle consists of the three primary colors and the three secondary colors.

Except for critical work, in color photography you usually need not know precisely what colors a filter absorbs and transmits. It is enough that you realize that a color filter paints a color photograph with its color, sometimes promoting the colors more than the objects.

Such a promotion can't happen in black-and-white photography. In black-and-white, a color filter only lightens and darkens objects with shades of gray. Depicted in shades of gray, objects retain their importance. They cannot be overwhelmed by color. In black-and-white photography you need to know if a filter lightens or darkens an object.

We mentioned a filter lightens its own color in a black-and-white photograph. We didn't explain how. It does so by making the picture mainly with its color of light. For example, in an unfiltered picture, red, green, and blue light and all their color combinations reach the film to make a

With a color circle you can relate the three primary colors, red, green, and blue, and the three secondary colors, magenta, cyan, and yellow. A filter of any of these colors will pass light of its own color and of the colors adjacent to it on the circle. It blocks some or all of the light from the other colors.

correct exposure. When you use a red filter, however, it absorbs the blue and green light. They never reach the film. You make up for the loss of blue and green light by letting in more red light with an increase in exposure. This means the picture is made almost solely from red light. The additional red light let in from red-reflecting objects makes them appear lighter (you might say they are selectively overexposed).

The light blocked from greenish and bluish objects makes them appear darker (they are selectively underexposed). Remember, many objects that reflect some red light are colored other than red—yellow or orange, for instance. They, too, are lightened in tone.

In density, color filters range from light to dark. A dark red filter blocks out much more green and blue light than a light red filter does. For instance, a deep red filter transmits only a trace of blue and green light, whereas a light red filter passes a considerable amount of blue and

green light. Upon request, filter manufacturers will usually provide you with graphs of color transmission curves for their filters that show precisely which and how much different colors of light are transmitted.

Such a graph is shown on this page. Except for critical uses, it is enough that you know that no filter is one hundred percent perfect in the colors it absorbs and transmits. For information on the critical use of filters, you might like to read *KODAK Filters for Scientific and Technical Uses*, Kodak Publication No. B-3.

A spectral transmission curve precisely graphs the percentage of transmission of different light wavelengths. This graph indicates transmission for a No. 58 green filter. The color bar indicates the colors of light and ultraviolet and infrared radiation corresponding to different wavelengths.

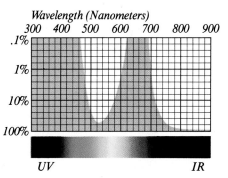

Wavelength (Nanometers)

| 300 | 400 | 500 | 600 | 700 | 800 | 900 |

.1%
1%
10%
100%

UV IR

A red filter transmits primarily red light and blocks most of the blue and green light.

A blue filter transmits primarily blue light and blocks most of the red and green light.

In black-and-white photography, colors similar to that of the filter are lightened in the photograph and dissimilar colors are darkened.

No. 25 red filter

No. 38A blue filter

No filter

No. 58 green filter

FILTER FACTORS

Because filters absorb some of the light striking them, you need to increase the exposure to make up for that absorbed light. The required exposure increase may be automatically indicated by a through-the-lens metering system common to SLR cameras or you may have to use a filter factor. Many through-the-lens meter systems accurately measure the light from all colors of filters while others stumble on certain colors—particularly deep red. Check your camera manual for specific details on using filters with your metering system.

If you can't find the camera manual, you can make a simple check by making exposure readings with and without a filter in front of the lens. First make an exposure reading without the filter attached. Then check that the reading with the filter in place matches the exposure increase indicated by the table on this page. If it's within 1/2 stop, you can probably use your meter with a filter in place (You might want to confirm its accuracy with several filter colors). If it doesn't approximate the exposure increase indicated by the table, use the filter factor as described in the next paragraph.

The filter factor indicates the exposure increase required for a specific filter. You multiply the filter factor times the indicated shutter speed for a meter reading taken without the filter in place. For example, the filter factor is 4 for a No. 11 yellowish-green filter. Without the filter in place, the meter indicates an exposure of 1/250 second at $f/11$.

$4 \times 1/250 = 4/250 \cong 1/60$ second shutter speed. With a No. 11 yellowish-green filter in place, the exposure is 1/60 second at $f/11$. You can, of course, also open the aperture by the corresponding number of stops rather than use a slower shutter speed. A filter factor of 4 represents a

2-stop increase which translates to an exposure of 1/250 second at $f/5.6$.

Published filter factors apply to average conditions. If your results aren't satisfactory when you use the published factors, establish your own factors by making exposure tests.

In practice, you can take some liberty in applying filter factors, particularly in using yellow filters for sky control with black-and-white film. For example, if you intentionally cause a slight underexposure, you may increase the contrast in the sky.

The filter-factor value depends on the light source and film type, in addition to the absorption of the filter. A No. 15 deep yellow filter has a factor of 2.5 with KODAK PLUS-X Pan Film and similar films when used in daylight. However, when you use tungsten light with these films, the filter factor is 1.5.

The reason for the difference in factors is understandable when you consider the color quality of the light sources. Daylight contains much ultraviolet radiation and blue light. Light from photoflood and other tungsten lamps contains less blue and much less ultraviolet. Since the No. 15 filter is deep yellow, it stops a higher proportion of usable light from daylight than from tungsten light; therefore, it requires more exposure compensation when you use it in daylight.

You don't need to know everything about filters to use them effectively. The tables in this book, in the *KODAK Pocket Guide to 35mm Photography* (AR-22), *KODAK Professional Photoguide* (R-28), or *KODAK Filters for Scientific and Technical Uses* (B-3) sold by photo dealers, can help you select the proper filter.

FILTER FACTORS FOR KODAK BLACK-AND-WHITE FILMS

Filter number	Color of filter	Verichrome Pan, Plus-X Pan, Panatomic-X, and Tri-X Pan Films			
		Daylight		Tungsten	
		Increase the exposure time by this factor	Open the lens by (f-stops)	Increase the exposure time by this factor	Open the lens by (f-stops)
3	Light Yellow	1.5	⅔	—	—
4	Yellow	1.5	⅔	1.5	⅔
6	Light Yellow	1.5	⅔	1.5	⅔
8	Yellow	2 (1.5)*	1 (⅔)*	1.5	⅔
9	Deep Yellow	2	1	1.5	⅔
11	Yellowish-Green	4	2	4	2
12	Deep Yellow	2	1	1.5	⅔
13	Dark Yellow-Green	5	2⅓	4	2
15	Deep Yellow	2.5 (2.0)*	1⅓ (1)*	1.5	⅔
21	Orange	5	2⅓	4	2
23A	Light Red	6	2⅔	3	1⅔
25	Red	8 (3)*	3 (1⅔)*	5	2⅓
29	Deep Red	16	4	8	3
47	Blue	6	2⅔	12	3⅔
47B	Deep Blue	8	3	16	4
50	Deep Blue	20	4⅓	40	5⅓
58	Green	6	2⅔	6	2⅔
61	Deep Green	12	3⅔	12	3⅔
Polarizing screen—Gray		2.5	1⅓	2.5	1⅓

*For KODAK Technical Pan Film

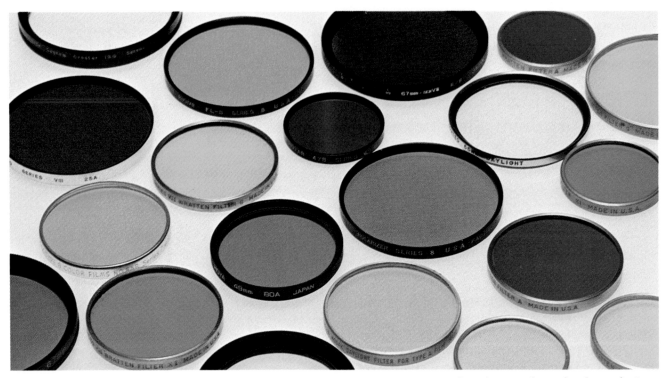

FORMS OF FILTERS

With a few variations, filters usually take on one of two basic forms: The glass filter mounted in a metal or thermoplastic ring or the unmounted square filter made of glass, plastic or gelatin. Some of the glass filters are solid dyed-in-the-mass glass. Others consist of a glass sandwich with the filter in the middle. The glass is colorless. The filter is colored. The filter can be either colored gelatin or a colored bonding medium that holds the glass sandwich together. Many glass filters are coated to reduce flare and internal reflections.

Two types of rings are used to hold glass filters:

1. The threaded ring that screws directly into the lens barrel.
2. The unthreaded ring, known as a series-size filter, that is sandwiched between an adapter and a retaining ring.

Direct-Fitting Filters

By far the most popular and most readily available filter is the glass filter mounted in the threaded ring that screws directly into the front of the lens barrel. Durable and fuss-free, it simplifies a photographer's life. This kind of filter comes in a specific diameter measured in millimetres. It fits lenses with the same diameter as the filter. Look for the lens diameter on the front inside of the lens barrel. It is often followed by this mark, ∅, which stands for diameter. Don't confuse the diameter with the focal length of the lens which is also indicated on the front of the lens.

Bound in a sturdy metal or thermoplastic ring, glass filters are available in a wide range of sizes and colors.

On the filter rim you can find the diameter measurement indicating what diameter lenses the filter fits.

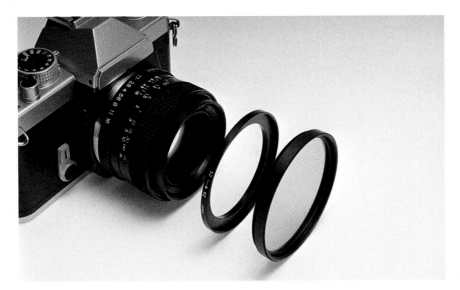

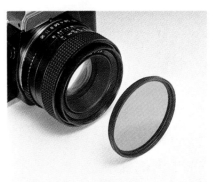

Direct-fitting threaded filters can be used with different diameter lenses by using the appropriate adapter ring.

Seemingly, a direct-fitting filter has a disadvantage in that it fits only a lens of the same diameter. Thus, a 55 mm diameter filter would fit only a 55 mm diameter lens. Supposedly, you would have to duplicate your filters to fit other diameter lenses. A costly proposition, indeed. Fortunately, there's an easy solution called adapters. Many companies offer adapters that let you fit a filter to lenses of different diameters. These adapters are called step-up and step-down rings. With a step-up ring you can use a 55 mm filter over a 52 mm diameter lens and with a step-down ring you can use it over a 58 mm diameter lens. Usually it's better to adapt a larger filter to a smaller lens, but within limits you can do just the opposite. Check for vignetting with wide-angle lenses when you use a filter smaller than the diameter of the lens.

Series-Size Filters

Also available, but harder to come by and less used than they once were, are series-size filters. A series-size filter is mounted in an unthreaded ring and is fastened to the lens by sandwiching the filter between an adapter and a retaining ring. The retaining ring screws into the adapter, holding the filter in place. The adapter screws into the lens barrel, fastening the filter to the lens. One retaining ring serves for many adapters. By using the appropriate adapters, you can fit a series-size filter to many different diameter lenses. For instance, with appropriate adapters, you can fasten a series 8 filter to a lens of 52 mm diameter or to a lens of 67 mm diameter. Occasionally a special-effects filter may be mounted in a threaded series-size ring that screws directly into an adapter without a retaining ring. The chart on this page indicates the approximate range of lens diameters different series-size filters will fit.

Although series-size filters are usually cheaper than direct-fitting filters, they do have a drawback. That drawback comes under storage and retrieval. Finding the needed pieces can take as much time as looking for last year's Christmas decorations. When the sun is dipping below the horizon, and you've found the orange filter and the retaining ring but can't find the appropriate adapter which has burrowed into the bottom of your camera bag, you might not relish your series-size filters any more. If you're neat and orderly, no problem. If you aren't, beware.

A direct-fitting threaded filter fastens right onto the lens.

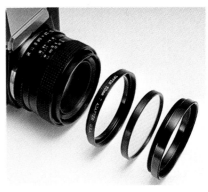

An unthreaded series-size filter is sandwiched between a retaining ring and an adapter. The adapter fastens to the lens.

SIZE RANGE OF SERIES-TYPE ADAPTERS

Series number	Approximate millimetre range
5	28 to 36
6	31 to 47
7	44 to 56
8	51 to 69
9	62 to 85

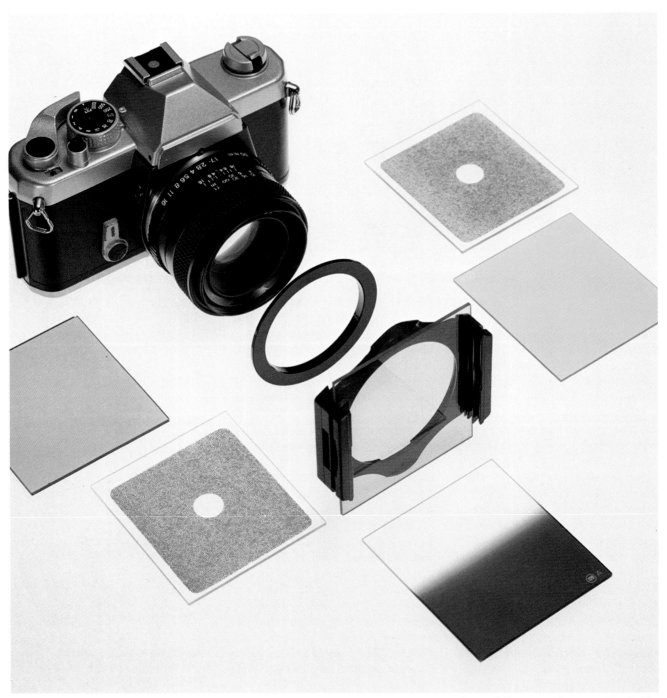

A typical filter system features a filter holder and several sizes of adapters that fasten the numerous color and special-effects filters to your lenses.

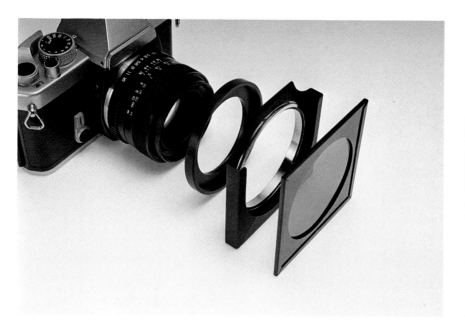

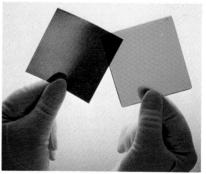

Square filters are available in plastic, gelatin (shown) and glass.

A KODAK Gelatin Filter Frame and a KODAK Gelatin Filter Frame Holder will hold gelatin filters flat. To attach the holder to a lens you need the appropriate adapter sold by independent companies.

Square Filters

Square filters are made of glass, gelatin film, or plastic. The glass filters are more scratch resistant than the others.

Made of gelatin film, KODAK WRATTEN Gelatin Filters are comparatively inexpensive. They are available in a great range of colors, including all the numbered filters mentioned in this book, and offer excellent optical purity. Handle them gingerly to prevent scratches. These gelatin filter squares are stocked in the following sizes: 50 mm, 75 mm, and 100 mm. By using special devices, such as a KODAK Gelatin Filter Frame Holder and a KODAK Gelatin Filter Frame, along with an appropriate adapter, you can attach gelatin filters to your camera.

Plastic square filters, also available in many colors, are typically part of a filter system. Such systems usually include a variety of correction filters, color contrast filters, and special-effects filters. The filters fit into a holder that is fastened to the front of the lens with an adapter ring. Once the holder is on you can easily and quickly slip filters in and out of it. By changing adapters, one size filter can be used with many diameter lenses. Most of the plastic filters are made of a tough, scratch-resistant plastic.

FILTER DESIGNATIONS

Sometime you might come across filter designations such as K2, A, G. These were assigned many years ago. Back then the number of filters was quite small and a simple identification system sufficed. Not so today. There are many filters and the present numbering system was adopted to accommodate them. Because older publications often refer only to the older designations, both current and discontinued designations are shown here.

Designations discontinued	*current*	*color*
K1	No. 6	light yellow
K2	No. 8	yellow
K3	No. 9	deep yellow
X1	No. 11	yellowish-green
G	No. 15	deep yellow
A	No. 25	red
F	No. 29	deep red
C5	No. 47	blue
C4	No. 49	deep blue
B	No. 58	green
N	No. 61	deep green

CARE OF FILTERS

Gelatin Filters

Gelatin filters are easily scratched and damaged, so handle them by the edges only. Remove dust particles by brushing gently with a clean, dry camel's-hair brush or by gently blowing air across the surfaces. To cut a gelatin filter, place it between two sheets of clean paper for protection while you cut with a pair of sharp scissors. Store these filters in a dust-free container in a cool, dry place.

Glass Filters

Glass filters require the same care and handling as your camera lens. You can clean them with a soft, lintless cloth slightly moistened with a cleaner such as KODAK Lens Cleaner. Don't get any moisture on the cemented edges of the filter laminated between glass squares. You can clean glass filters and lens attachments with KODAK Lens Cleaning Paper.

Keep your lens accessories in their original container for protection when you're not using them. Handle them only by the edges to avoid fingerprints, which degrade picture quality.

Stability of Filters

Filter dyes may change color in time, particularly when exposed to daylight for long periods of time. Extreme temperatures and high humidity may accelerate a change in color. You can prolong the life of your filters by storing them in a dark, cool, dry place.

Filters for black-and-white films

Right off the bat, let's repeat the most important thing you need to know about filters for black-and-white film. In the final black-and-white print, a filter lightens objects of its own color and darkens objects lacking its color. If you remember that, and we've mentioned it before, then you'll always have a good idea of how to choose a filter and what its effect will be.

In combination, a polarizing filter and a No. 29 deep red filter nearly blacken the blue sky.

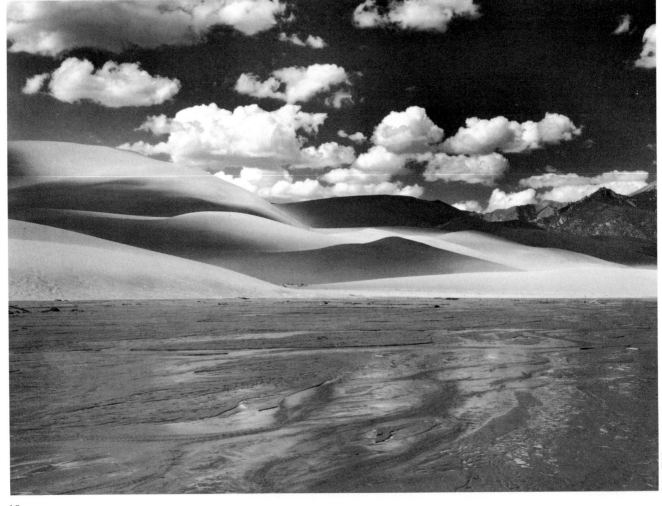

Robert Walch

THINK GRAY FOR BLACK-AND-WHITE FILM

The reason for using filters in black-and-white photography might seem obscure. In color photography you know that filters can change the color of a picture. A color change is obvious and often dramatic. But in black-and-white photography, filters change only gray tones. Since you see in color, the changing of gray tones may seem rather subtle, even superfluous. But it isn't.

Objects readily apparent in color, even boldly contrasting, sometimes teeter on the brink of invisibility when rendered in black-and-white because they can blend together in similar shades of gray. Through filtration, you can change what would have been similar shades of gray into different shades of gray. Though gray is but one word, it stretches wide. From light to medium to dark, there are roughly 200 shades of gray that your eye can discern. Achieving a contrast and gradation between those shades assumes supreme importance in making a black-and-white photograph.

COLOR SENSITIVITY

Most black-and-white films are sensitive to all the colors you can see. Films sensitive to a full range of colors are called panchromatic. They are the mainstay of general, everyday photography. KODAK PLUS-X Pan Film and KODAK TRI-X Pan Film are two popular panchromatic films. Much of the filtering required for black-and-white photographs results because the eye and black-and-white film respond differently to light. For instance, film is extra sensitive to blue light, showing it lighter in the final print than originally perceived by the eye. Black-and-white film also responds to ultraviolet radiation which you can't even see. The difference becomes apparent when some scenes in a photograph don't quite appear as you remembered them. For the most part, this difference is a shift in brightness caused by the film's sensitivity to blue light and ultraviolet radiation.

Black-and-white film records some colors as the same shade of gray. With filtration, the colors can be changed into different shades of gray and, in this instance, making the nearly invisible once again visible.

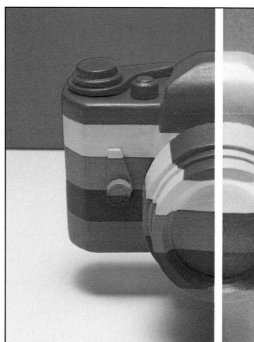
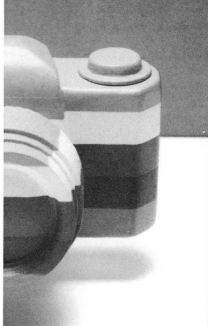

By comparing the black-and-white photograph with the color photograph, you get a good idea of the shades of gray corresponding to different colors.

BRIGHTNESS RELATIONSHIPS

Filtration can preserve the proper brightness relationship between colors. Imagine an orange basketball against a deep blue sky. To your eye, the basketball probably appears brighter than the sky. But film responds more to the blue light and ultraviolet radiation in the sky than to the orange basketball. It will show the sky lighter than the basketball. For similar reasons, yellow and red objects appear darker in a print than in the original scene. Although it is unlikely to bowl you over, a reversed brightness relationship when seen in the final print probably will linger with you as a nagging feeling that something is somehow amiss.

By now you realize that behind every good filter is a good reason for using it. However, the reasons do not number as many as the filters. In fact, the reasons can be sifted away to one big one. That big reason is the sky. Take away the sky and you take away a large chunk of the need for filters. For general black-and-white photography, probably two thirds of filtration involves the sky. This vast expanse of blue reacts to filtration like a three-way light bulb. You can lighten it. You can darken it. Or you can make it just right. (You can even make it appear clearer or hazier.) The sky is important to black-and-white filtration not just because it's photographed so often but because it commonly takes up such a large part of a picture. Its rendering often rules one's perception of a photograph.

A filter can help you darken skies and draw out the texture of sand.

Ralph S. Sheperd

TYPES OF BLACK-AND-WHITE FILTERS

A smaller (but no less important) part of black-and-white filtration involves lightening and darkening foliage and flowers for proper contrast, rendering correct skin tones, and eliminating haze. The filters that accomplish all these tasks for black-and-white photography fall into three categories:

1. Correction filters
2. Contrast filters
3. Haze filters

Correction Filters

Correction filters are brightness adjusters. With them, the final print shows the brightnesses expected by your eye. They're needed because the eye and film don't always see eye to eye. Let's use our ever faithful blue sky as an example. Without a correction filter, the blue sky appears too light in a print. It's so light that any cream puff clouds in the scene blend in with it. That can be disheartening. With a correction filter, the sky and clouds appear as we expect them to. Nothing is darker. Nothing is lighter. They're just about normal—as normal as a color-perceiving creature can expect of white clouds and blue sky rendered in a black-and-white print.

The correction filter used to render the sky normal is a No. 8 yellow filter. As shown by the color circle on page 11, yellow is the complement of blue and thus blocks blue light. Blocking blue light darkens the sky. A No. 8 filter is light yellow so it blocks just enough blue light that the sky appears normal. Be aware though that you may not want a normal sky. You might want it darker. A darker sky is more dramatic and can be achieved with contrast filters (see page 25).

*The extra sensitivity of black-and-white film to blue light and ultraviolet radiation causes blue skies to be rendered pale, **center,** in black-and-white prints. In the bottom photo, a No. 8 yellow filter blocks some of the blue light and ultraviolet radiation darkening the sky so it corresponds more closely to what the eye originally saw.*

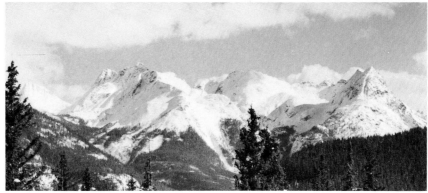

Neil Montanus

Tungsten Light

Correction filters occasionally come in handy when taking pictures by tungsten light. Tungsten lamps throw off an abundance of red light. The excess of red light knocks the gray tones in the print slightly out of kilter. Without comparison pictures you'd probably not notice that the brightnesses were off. Yet they are. The variance in gray tones is usually slight and probably won't displease you. If it doesn't, don't fret about filtration. However, if for some reason you need to show flesh tones and other tones as

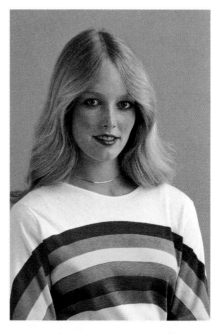

Here's how the subject originally looked under tungsten lighting.

they would appear in daylight, use a correction filter. For the most natural-looking effect, use a No. 11 yellowish-green filter with Kodak panchromatic films in tungsten light. The No. 11 filter absorbs the extra red light. Blue light and ultraviolet radiation are also absorbed, but the effect is not noticeable because tungsten lamps radiate such a small amount of blue light and UV radiation.

Without filtration, the abundance of yellow-red light in tungsten lighting alters the original brightness relationships.

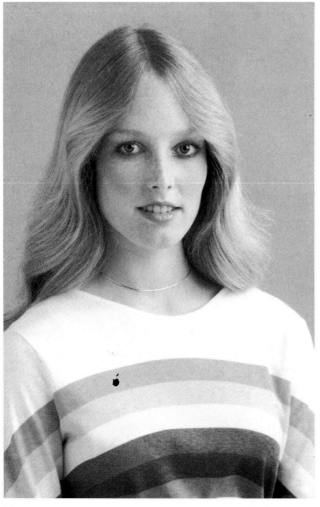

A No. 11 yellowish-green filter blocks some of the blue and red light and restores the normal brightness relationships.

Neil Montanus

Contrast Filters

When you want to photograph a scene not as you see it but as you imagine it, use a contrast filter. Contrast filters lighten and darken the grays in black-and-white prints. These grays correspond to the colors in the scene. When film records different colors as similar grays, a distressing merger can occur. The appropriate contrast filter can remedy the problem by darkening one gray and lightening the other. For example, the flowers and leaves of red geraniums photograph as nearly the same tone of gray. By using a No. 25 red filter, you can lighten the geranium flowers and darken the leaves. That is appropriate since you probably think of flowers as brighter than leaves. You can produce unusual effects in your black-and-white pictures when you understand how filters influence brightness relationships. To lighten an object, choose a filter the same color as the object. To darken an object, choose a filter that absorbs the color of the subject. Some of the more common contrast filters are the No. 15 deep yellow, No. 21 orange, No. 25 red, No. 47 blue, and No. 58 green. The table on page 31 will help you pick the filter you want.

A No. 21 orange filter was used for each of these pictures. It helps draw out the texture of the yellow black-eyed Susans. It lightens the orange Turk's cap lilies and darkens the foliage background so the lilies stand out better.

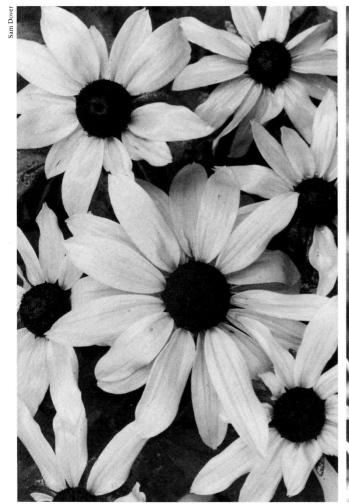

KODACHROME 64 Film

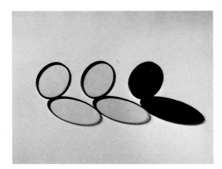

The No. 8, No. 15, and No. 25 filters, shown from left to right above, were used to successively darken the sky in the bottom row of pictures. Unaffected by filtration, the clouds stand out by contrast as the sky grows darker.

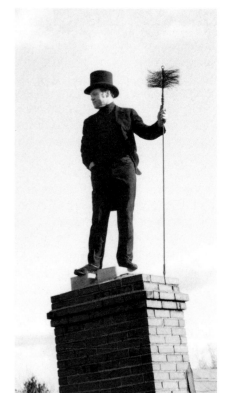

No filter

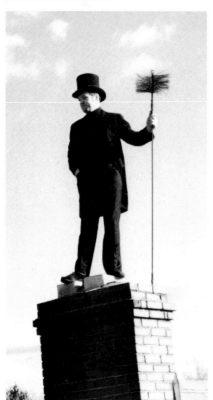

No. 8 yellow filter

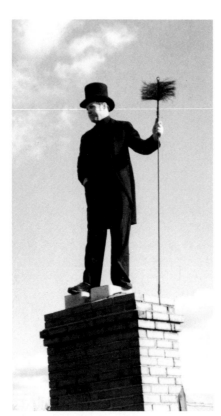

No. 15 deep yellow filter

No. 25 red filter

24

Derek Doeffinger

Special uses: *darkening blue skies*
One of the most frequent uses of contrast filters in black-and-white photography is to darken a blue sky so that white clouds stand out. As mentioned, a No. 8 yellow filter reproduces the blue sky more as your eyes see it. However, your mind often unduly convinces your eye that those fluffy white clouds and deep blue sky have much more contrast than they actually do. Thus the sky rendition from a No. 8 yellow filter is often too light to please you. A No. 15 deep-yellow filter produces a darker sky. To really emphasize the clouds and blue sky, opt for a No. 25 red or a No. 29 deep-red filter. Then the effect will be even more dramatic than you could have envisioned. These same filters can be used to darken blue water, though the effect on water is somewhat less than that on the sky because of reflections.

A polarizing filter provides another method of darkening a blue sky. You obtain the maximum effect when you take pictures at right angles to the sun (for example, when your shoulder points to the sun the sky directly in front of and behind you will be most affected). With an overhead sun, only sky near the horizon can be darkened. For spectacular effects in black-and-white, try using a No. 25 red filter with a polarizing filter, the combination used on the opening shot of this chapter on page 18. For more information on polarizing filters, see page 34.

The sky may appear lighter in your pictures than you would expect for these reasons:

1. A misty sky does not photograph as dark as a clear blue sky. You can't darken an overcast sky by using a color filter.

2. The sky is frequently almost white at the horizon and shades to a more intense blue overhead. Therefore, the effect of the filter at the horizon is small, but becomes greater as you aim the camera upward.

3. The sky near the sun is less blue and less affected than the surrounding sky.

Sam Dover

For the picture on the right, a No. 25 red filter was used to darken the sky. The picture above shows the sky rendered without a filter.

Darkening an Overcast Sky

You cannot darken an overcast sky with a contrast filter. An overcast sky has roughly equal amounts of red, green, and blue light in it, making it colorless. Its gray appearance results from the low reflectance of white light (roughly 18 percent reflectance for a medium-gray object compared with 90 percent for a white object). The only way to darken an overcast sky is with a split-field neutral density filter. A split-field neutral density filter has one half clear glass and one half gray glass. The gray glass is the neutral density filter. A neutral density filter simply reduces the amount of light without changing its color. To darken an overcast sky, align the neutral density portion of the split-field filter to the sky (you also darken everything else covered by the filter). See page 38 for more on neutral density filters.

Because it has a neutral color, an overcast sky, **below,** *is unaffected by a filter used with black-and-white film. You can darken an overcast sky by aligning a neutral density filter over the sky,* **right.** *Since a neutral density filter does not affect the color of light, it works equally well with color and black-and-white film.*

No filter *No. 15 yellow filter*

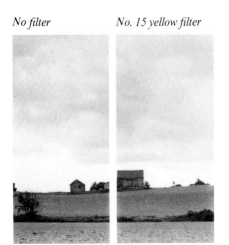

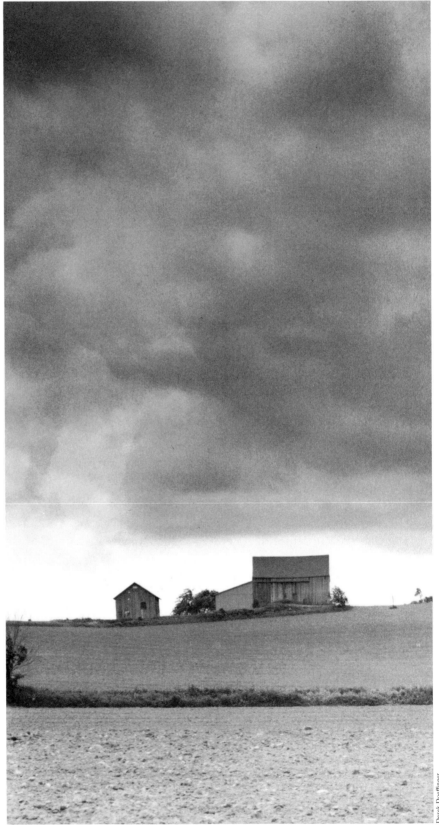

Stressing Texture of Sand and Snow

Shadows define the depth and shapes of things. In sunlit pictures of sand or snow, the perception of texture depends on the tiny shadows thrown by grains of sand or flakes of snow. These shadows show up lighter on film because they reflect the blue sky light to which the film is sensitive. A yellow filter blocks some of that blue light, darkening the shadows and stressing the texture.

The top picture is unfiltered. Notice how light the shadows on snow appear when a filter isn't used. The extra sensitivity of black-and-white film to blue light reflected from the sky lightens the shadows. By blocking some of the blue light, a No. 15 deep yellow filter darkens the shadows and highlights the texture in the bottom picture.

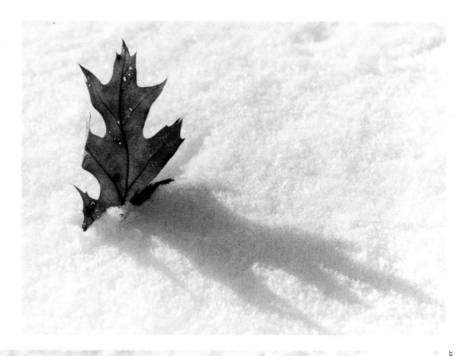

Sam Dover

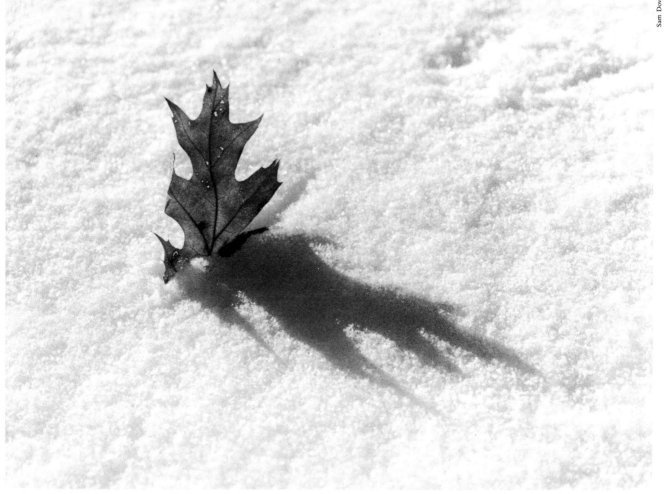

Unfilte

N

No

Special uses: *skin tones*

The same filters that darken blue skies also lighten skin tones—it's an effect you may or may not want. In portraits with the blue sky as a background you can preserve the skin tones and darken the blue sky by using a No. 11 yellowish-green, a No. 15 deep yellow, or a polarizing filter. Avoid overexposing the sky, or the effect of the filter will be weakened.

If the sky is not in your picture and you just want good skin tones, you are better off without a filter. The film does a good job. However, if you are into portraiture you might want to alter skin tones for special effects or for contrast with clothes or the background. To give a man a more swarthy, masculine look, use a No. 56 light green or a No. 58 green filter. Since skin is reddish colored, the green filter absorbs some of the red light, darkening the skin. For a blonde-haired person you might choose a No. 15 deep yellow filter. It lightens the hair with little change of the skin tones.

With a No. 25 red or a No. 29 deep-red filter you can drastically lighten skin tones. Sometimes ghoulish looking, the milky white tones produced by the red filter can also be haunting and ethereal. A red filter is sometimes used in fashion photography to suppress blemishes and stress shape. The lightening of the skin is usually more pronounced with light-skinned people than with dark-skinned people.

No. 11 yellow-green filter: With this filter, you can preserve natural skin tones yet darken a blue sky.

John Menihan

Unfiltered: Skin tones appear natural when no filtration is used.

No. 8 yellow filter: Although skin tones are lightened slightly, they still appear natural.

No. 15 deep yellow filter: Skin tones are more noticeably lightened, but still appear natural.

No. 25 red filter: Skin tones are greatly lightened, giving the skin a very smooth appearance and emphasizing facial shapes.

No. 47 blue filter: Skin tones and hair are darkened. The black woman's skin appears exceptionally smooth.

No. 58 green filter: Lips are dramatically darkened. Increased contrast adds dimension to the faces.

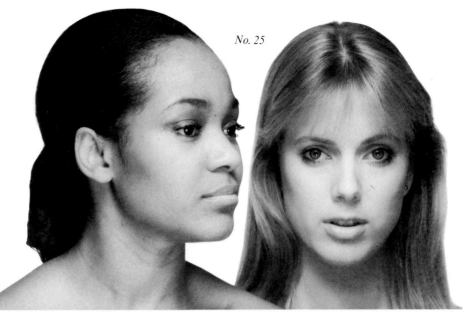

No. 25

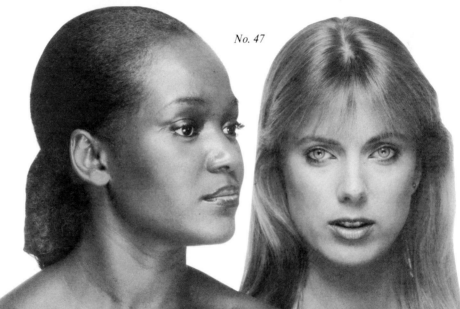

No. 47

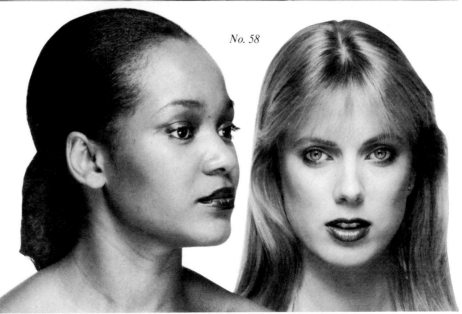

No. 58

Neil Montanus

When unfiltered, distant landscape shots tend to accentuate the haze because the film is more sensitive to blue light and ultraviolet radiation than the eye.

A No. 47 blue filter builds up the haze, obscuring the background.

A No. 25 red filter cuts through the haze, giving greater clarity.

Charles Brethauer

Haze filters

Haze filters cut through the haze to give clearer pictures of distant scenes. They belong in the camera bag of every travelling photographer taking black-and-white pictures. How often have you walked out on an observation deck or pulled over at a highway lookout only to find yourself admiring the haze? This is the haze syndrome. You needn't always suffer from it, although sometimes you should. True atmospheric haze is bluish. It results from the scattering of light by atmospheric dust, water vapor, and the air itself. Haze also scatters ultraviolet radiation that you can't see but the film can. It records the scattered ultraviolet radiation giving your pictures more haze than you remembered.

Once we tell you how, your inclination will be to cut right through the haze. Nothing wrong with that—if you want to show details in the distance. However, the haze itself is a

way of stressing distance. Its buildup causes subjects to increasingly pale into the distance, which cues you to their distance. For instance, tourists in mountain regions often underestimate the distance to a nearby mountain. What they guessed to be a one-hour stroll turns into an all-day trek towards a mountain that never seems to come closer. The mountain only seemed close because the clear air didn't make it appear as pale as would have the hazier air at lower altitudes. Haze buildup not only suggests distance, it also separates foreground, midground, and background. Furthermore, it adds a light, airy feeling to a picture.

When confronted with haze, you have to decide whether to preserve, reduce, or increase it.

To preserve the haze in the scene, shoot without a filter or with a No. 8 yellow filter. The No. 8 filter is suggested because, unfiltered, the film

might increase the haze effect slightly.

To reduce the haze, use a No. 15 deep yellow or a No. 25 red filter. The No. 25 red filter gives a greater reduction of haze. Don't count on completely eliminating the appearance of haze. It usually won't happen.

To increase haze, use a No. 47 blue or a No. 38 light blue filter. Since the film accentuates the haze effect anyway, you might get the effect you want without using a filter. By using a filter on an already hazy day, you can nearly obscure the background.

Skylight or haze filters for color film do not penetrate haze. These filters reduce the bluishness in pictures made in the shade and on overcast days and pictures of distant scenes. A filter can't cut through fog or mist. Mist and fog are white and composed of water droplets. A filter does not affect neutral-colored objects (white, gray, black).

30

Neil Montanus

The buildup of haze with distance can be used to stress distance and to separate the scene into successive planes.

FILTER RECOMMENDATIONS FOR BLACK-AND-WHITE FILMS IN DAYLIGHT

Subject	Effect desired	Suggested filter
Blue sky	Natural	No. 8 Yellow
	Darkened	No. 15 Deep Yellow
	Spectacular	No. 25 Red
	Almost black	No. 29 Deep Red
	Night effect	No. 25 Red, plus polarizing filter
Marine scenes when sky is blue	Natural	No. 8 Yellow
	Water dark	No. 15 Deep Yellow
Sunsets	Natural	None or No. 8 Yellow
	Increased brilliance	No. 15 Deep Yellow or No. 25 Red
Distant landscapes	Increased haze effect	No. 47 Blue
	Very slight addition of haze	None
	Natural	No. 8 Yellow
	Haze reduction	No. 15 Deep Yellow
	Greater haze reduction	No. 25 Red or No. 29 Deep Red
Foliage	Natural	No. 8 Yellow or No. 11 Yellowish-Green
	Light	No. 58 Green
Outdoor portraits against sky	Natural	No. 11 Yellowish-Green, No. 8 Yellow, or polarizing filter
Architectural stone, wood, sand, snow when sunlit or under blue sky	Natural	No. 8 Yellow
	Enhanced texture rendering	No. 15 Deep Yellow or No. 25 Red

Filters for black-and-white and color films

Although color filters produce quite different results in black-and-white and color photography, there are two filters that yield similar results in both black-and-white and color pictures. They are the polarizing filter and the neutral density filter. Since they don't affect the color of light, their functions in black-and-white photos are the same as in color photos. Although they're among the least used and least understood of all filters, they are extremely versatile. Their effects often add the finishing touch to a photograph.

A polarizing filter was used to darken the blue sky in the picture on the opposite page.

© 1981 Jake Rajs

POLARIZING FILTER

A polarizing filter is usually mounted in a two-ring holder. The threaded inner ring attaches to the lens while the outer ring holds the filter and can be fully rotated. Explaining and understanding how a polarizing filter works is a greal deal more difficult than using one. So first let's see what it can do and how to use it, and then we'll see how it works.

A polarizing filter does three important things:

1. Darkens blue skies.
2. Removes or reduces reflections from nonmetallic surfaces such as water and glass.
3. Increases the color saturation (intensity) of color pictures.

The polarizing filter is mounted in a rim that you can rotate to adjust the polarizing effect.

DARKENING A BLUE SKY

The polarizing filter does for color pictures what a red filter does for your black-and-white pictures—it makes those fluffy white clouds pop out from the sky. It does so by darkening the blue sky. The darkening is even adjustable. You can make the sky dark blue, medium dark blue, medium blue, and so on. To get maximum darkening of the sky take pictures at right angles to the sun (shoulder pointing at sun) when the sun is fairly low in the sky. The

darkening diminishes and disappears as you turn to face the sun or turn your back to the sun. When the sun is overhead, only a small arc of sky near the horizon can be darkened. With a single-lens reflex (SLR) camera, you can see the darkening provided. Simply look through the viewfinder as you rotate the filter. Stop when you see the

effect you want. Some polarizing filters have a small handle that you point at the sun to position the filter for the maximum effect.

Unfiltered, color film renders a blue sky with nearly normal brightness.

With a polarizing filter, a blue sky can be rendered darker.

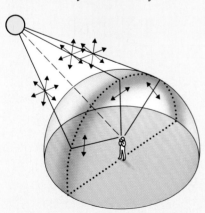

To find the part of the sky that can be most darkened with a polarizing filter, point your shoulder at the sun. The sky directly in front and behind you can be most darkened. If the sun is near the horizon, the sky overhead can also be darkened.

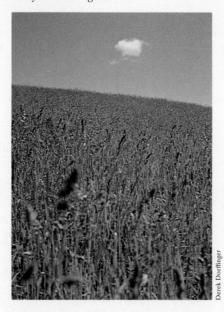

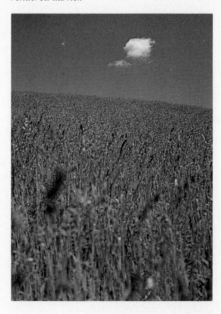

Don't be too quick on the draw with a polarizing filter. Just because blue sky appears in the viewfinder doesn't mean you have to make it darker. This is especially true with cloudless skies when a dark-colored subject, such as a deep red barn, is seen against the sky. By darkening the sky, you reduce the contrast between the barn and sky, an effect you normally don't want. However, such darkening would increase the contrast between the sky and a white steeple or between the sky and white clouds, effects often desired. Color film records the blue sky approximately as your eyes see it. When taking a picture, look through the viewfinder and decide if the sky looks better with or without the polarizing effect.

One added benefit of a polarizing filter is its ability to cut through haze. It is often more effective than a haze filter for color film because it can reduce more of the blue light scattered by haze to which the film is sensitive.

One drawback in using a polarizing filter is that a few metering systems balk at polarized light. They just won't give accurate exposures. That becomes obvious when your pictures (taken with a polarizing filter) show incorrect exposure. You'll have to use the filter factor to adjust exposure. Most often the filter factor is 2.5 (1 1/3 stops). However, it varies slightly depending on the manufacturer, so check the filter factor for your brand of filter.

CONTROLLING REFLECTIONS

You can also use a polarizing filter to reduce or eliminate reflections from water, glass, and other shiny surfaces such as tabletops. You can't eliminate reflections from bare metal surfaces because the reflected light is not polarized (see the explanation of how polarizing filters work). Again, the viewing angle determines the maximum effect. At an angle of approximately 35 degrees from the surface, you obtain the maximum reduction in reflections when the polarizer is rotated to the correct position. As you vary from this angle, the reflections return. Don't automatically reach for a polarizer to remove reflections. First consider whether the reflections help or hinder the picture. Then make your decision.

Without polarizing filter Neil Montanus

With polarizing filter

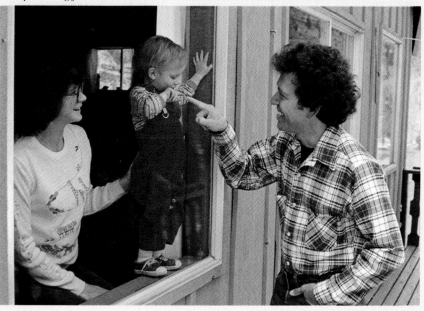

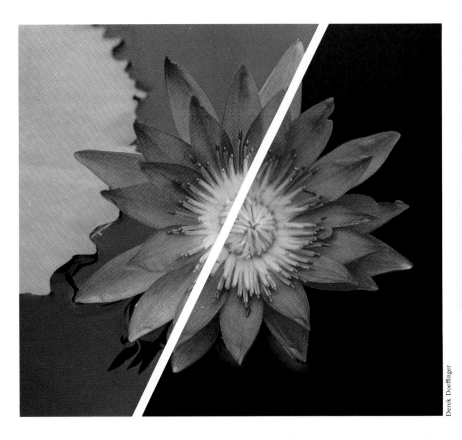

Derek Doeffinger

A polarizing filter can greatly increase color saturation by decreasing surface reflections which mask the colors. For rich, intense colors a polarizing filter is a great aid.

INCREASING SATURATION

A polarizing filter can even give your pictures richer colors. Flowers display intenser hues; wheat fields grow lusher. To many people, increasing color saturation sounds like a fine point, and it may be, but a good picture deserves it.

Although the increase in saturation is not always readily noticeable when seen through the camera, the comparison photos on this page show it clearly. The saturation increase results from a decrease in surface glare. Leaves, flowers, rocks, water, and just about every semismooth object have a surface sheen that diffusely reflects the light, masking some of the color beneath it. Reduction of these diffuse reflections with a polarizing filter intensifies the colors.

HOW POLARIZING FILTERS WORK

To understand how polarizing filters work, you need to know a few things about light. Light rays travel in straight lines. They also vibrate as they travel in straight lines, rather like a person on a pogo stick following the stripe down the center of a road. The person moves forward in a straight line but does so in an up and down motion. Each light ray vibrates in only one plane of direction (left and right, up and down, and so on). In normal light, all the rays vibrate in random directions. However, in polarized light the rays vibrate in the same direction (for example, left and right).

Light becomes polarized as it is scattered from the blue sky and reflected from shiny, nonmetallic objects. Selective sorting of individual rays causes the polarization. Selective sorting doesn't mean there's an assembly-line worker choosing and rejecting light rays. It means that more of those light rays vibrating along a certain plane are scattered or reflected than are light rays vibrating in other planes.

Think of yourself on the ground looking at the sky. Fifteen light rays are about to make a mad dash into the atmosphere. Five of them are vibrating up and down, five left and right, and five diagonally. In other words, they show random vibration before entering the atmosphere. Upon entering the atmosphere, they are knocked about and only a few reach your eyes. Of those transmitted to you only two vibrate up and down, only one left and right, but four vibrate diagonally. No longer do we have random vibration.

EXPOSURE

The 2.5 filter factor (1 1/3 stops) applies no matter how much you rotate the filter. Sometimes the loss of light poses a problem. Other times it offers a benefit. The problem arises when you use a polarizing filter with a slow-speed film and set the lens at a small aperture. That adds up to a slow shutter speed. On sunny days, you have two choices. Either use a tripod or open up one or two *f*-stops to get the shutter speed you want. On cloudy days, you'll also have two choices. Either use a tripod or high-speed film, such as KODAK EKTACHROME 400 Film or KODACOLOR VR 400 Film.

One benefit of the exposure factor is that it allows the polarizing filter to function as a medium neutral density filter. When excessive light prevents you from using a slower shutter speed or wider aperture, just fasten a polarizing filter to your lens.

A polarizing filter allowed the photographer to use a slow shutter speed to blur the water. The electric-like pattern is from specular reflections in the moving water.

Stephen J. Diehl, North-South Photography

These four make the light partially polarized. So polarization occurs when there's an abundance of light rays vibrating along any one plane. It's that simple (isn't it?). Depending on your viewing angle, the proportion of polarized light may increase or decrease. Nearly all reflected light has both polarized and unpolarized light, though at times the polarized portion may be a miniscule amount.

A polarizing filter works by blocking light that vibrates along the same plane (polarized light). Embedded in the polarizing filter are minute crystals. These crystals all have the same orientation. For a brief time you might think of them as forming a tennis racket with only vertical strings. Now think of the lights rays as paper plates. If the plates are polarized, they'll all be lined up in the same direction. The polarized plates will pass through the vertical strings of the tennis racket only when the strings are aligned with the narrow-edge of the plates. You have but to rotate the racket and the polarized plates will be blocked, darkening the blue sky or reducing reflections. Pass the plates and the blue sky will be light again and reflections will reappear. The darkening of blue sky or reduction of reflections depends solely on the blocking of polarized light. If there isn't much polarized light present, the effect will be weak. When the polarizing filter is passing polarized light, you see no effect on reflections or the sky. By rotating the filter 90 degrees, it will block any polarized light.

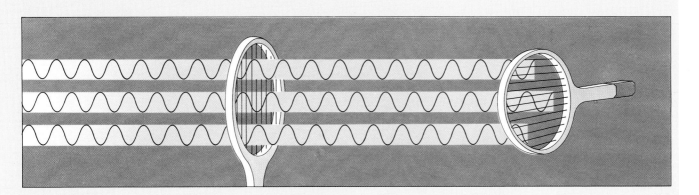

NEUTRAL DENSITY FILTERS

Cloaked in drab gray, neutral density filters are your dimmer switches. With two or three of them in hand, you can lessen the amount of light reaching the film without changing the colors because they block all colors equally. The results of light reduction are both practical and creative.

They're practical in that if you're outside taking pictures of a brilliant subject on a sunny day with high-speed film, you may get overexposure even with the fastest shutter speed and smallest aperture. A neutral density filter can save the day. It reduces the light so you can obtain correct exposure.

It's more likely, though, that you'll find ample opportunity to use them creatively. You can block enough light to use either a larger aperture or a slower shutter speed. A large aperture is especially effective in portraiture. You can give attention to your subject by making an out-of-focus background with shallow depth of field. Now that bewitching smile of your favorite subject won't have to compete for attention with the bicycles and trees in the background. The background will be out-of-focus. Portraits, flower studies, and many other subjects can benefit from an out-of-focus background.

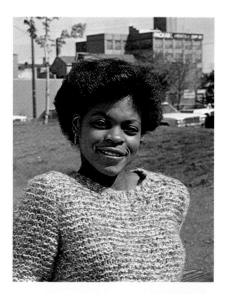

For the picture on the opposite page, a neutral density filter was used to obtain a slow shutter speed. The slow shutter speed rendered the cascading water as a soft blur.

For portraiture, a neutral density filter allows you to use a large aperture to throw the background out of focus and give emphasis to your subject. For the top picture the aperture was f/16. For the bottom picture it was f/1.8.

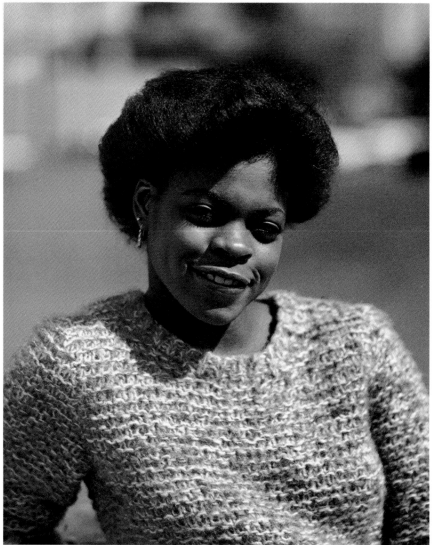

Neil Montanus

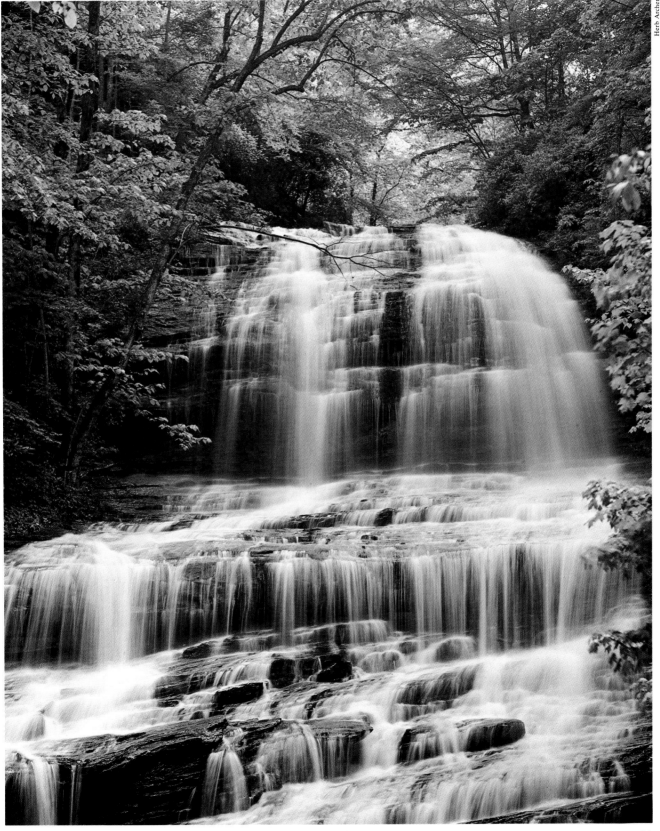

Herb Archer

Blur and Action

Anyone taking action photographs knows the benefit of slow shutter speeds. That benefit is blur. Blur means motion. In a still picture blur translates the flurry of wings, the stampede of hooves, and the charge of linemen. To create that blur you need a slow shutter speed. You also need the camera movements of panning and zooming, or holding the camera steady and letting the subject be the sole source of blur.

Panning creates a fairly sharp subject seen against blurred streaks in the background. Start out with a shutter speed approximating or doubling the speed in miles per hour of the subject (for example, 1/30 or 1/60 second shutter speed for a horse running at 30 mph). Since the results are somewhat unpredictable you should also bracket your shutter speeds (but more often, use a shutter

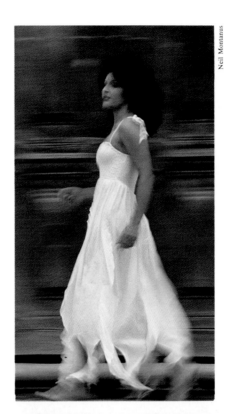

Neil Montanus

speed one step faster). To pan, you simply track the moving subject in your viewfinder and while moving the camera snap the picture as the subject passes in front of you. Prefocus on the spot where the subject will pass.

Often the best blurs come only from the subject moving while the camera is held still. Picture yourself being photographed as a cat leaps onto your lap. If the photographer uses a slow shutter speed, the cat will be a leaping blur and you'll be sharp. The contrast between blur and sharpness can be startling. You can

With a neutral density filter you can also use a slow shutter speed necessary to make an unusual panning shot like this one.

To blur the pole vaulter the photographer used a neutral density filter to obtain a slow shutter speed and mounted the camera on a tripod for steadiness.

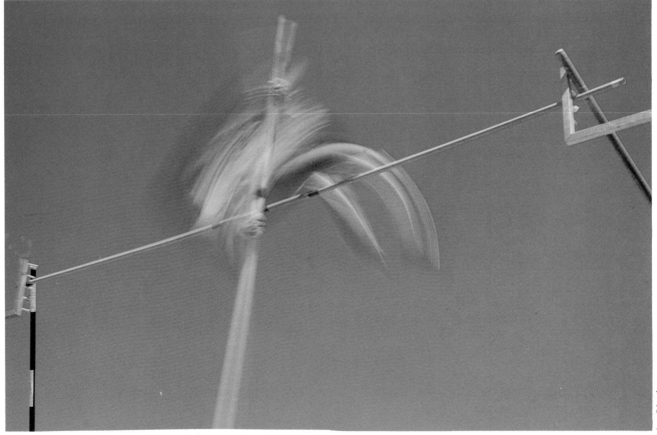

Jerry Schoenherr

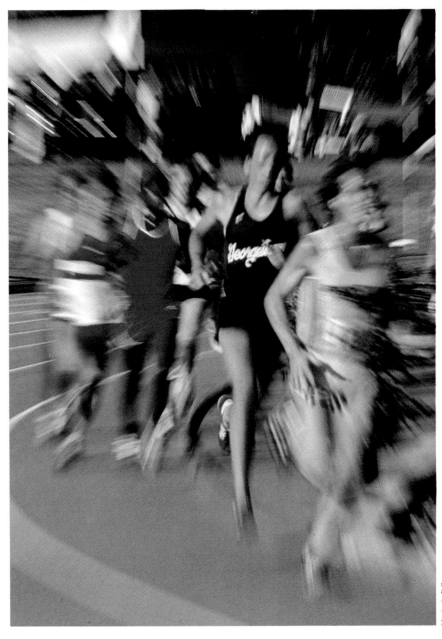

Shutter speeds of 1/15 second and slower necessary for zoom shots can easily be obtained by using a neutral density filter.

Neutral density filters are available in a variety of densities. You can sandwich two of them to create the density you want. The table on this page shows the density values of the neutral density filters and how much each filter reduces exposure. If you're planning on buying only one neutral density filter, get a very dense one such as a 0.9 filter which requires a 3-stop increase in shutter speed or aperture. That way you'll be able to choose a wide range of slow shutter speeds and wide apertures. Kodak offers a wide range of neutral density filters available as gelatin film squares.

Neutral density filters are available in different densities to block varying amounts of light.

NEUTRAL DENSITY FILTERS

Density	Reduces Exposure by (f-stops)
0.1	⅓
0.2	⅔
0.3	1
0.4	1⅓
0.5	1⅔
0.6	2
0.7	2⅓
0.8	2⅔
0.9	3
1.0	3⅓
2.0	6⅔
3.0	10
4.0	13⅓

even make things disappear. With a time exposure of a minute or longer, you can make rush-hour traffic vanish (assuming, perhaps unwisely, that the cars are moving). The exposure is long enough that moving subjects don't show on the film. This is a handy technique for photographing architecture when you don't want any people to show in the picture. For shutter speeds slower than 1/30 second, mount the camera on a tripod.

An effective zoom shot requires shutter speeds 1/15 second or slower. Of course you'll need a zoom lens and a tripod for extra sharp zoom lines. To zoom, position the subject in the center of the viewfinder and as you press the shutter release, pull or rotate the zooming collar through the full range of focal lengths.

Martin A. Folb

Filters for better color rendition

The eye perceives. Film records. Hairsplitting? Not really. In perceiving, human vision strives for color constancy in a world of inconstant light. To the eye, a face invariably appears face-colored, be it seen under fluorescent or tungsten lighting, or in the shade of midday. Not so for film, especially slide film. Film records the extra green of fluorescent lighting, the red of tungsten lighting, and the blue of midday shade. Film picks up the slightest shift in the color balance of a light source. Often a color shift is no problem. Sometimes it's desirable. When it's undesirable, you can use color correction filters to give your pictures normal colors. What colors are normal? For our purposes, we'll say normal colors are those seen in the white light of a sunny afternoon.

The scene below was photographed shortly before sunset. The right half of the picture shows the yellowish light from a setting sun. The left half was corrected with a No. 80C blue filter to show normal coloration.

WHEN YOU NEED A FILTER

Before you use a filter to correct colors, you have to know that the colors will not appear normal on film. Colors do not appear normal on film when the color balance of the light source varies greatly from the color balance required by the film.

Most color films are balanced for either tungsten light or daylight. The color sensitivities of these films match the amount of red, green, and blue light in the light source. Tungsten light radiates an abundance of yellow and red light. Tungsten-balanced film compensates by being less sensitive to the yellow and red light and more sensitive to the other colors. The result is pictures of normal coloration. Daylight films are balanced for the nearly white light of a sunny midday which contains roughly equal amounts of red, green, and blue light.

Light after sunset is bluish.

Light at sunset is orangish.

A No. 81C yellowish filter lessens the bluishness of portraits taken in open shade.

Without a filter, the face appears bluish in open shade.

LIGHT BALANCING FILTERS

Daylight is fickle. Its color varies from dawn to dusk. To correct a fickle light source you need a light balancing filter. These filters come in two series of colors ranging from a tinge to medium coloration. The 82 series is bluish; it counteracts excessive yellow light. The 81 series is yellowish; it counteracts excessive blue light. A typical example of excessive yellowish or orangish light is outdoors in early morning or late afternoon sunlight. At these times, the sun tinges everything with a warm, yellow light. Most people like this tinge. Many even seek it for their pictures. But on those occasions when you want to render colors as normal as possible, you would have to filter out the yellowish tinge with one of the bluish series 82 filters. To counteract the orangish light of sunset, you need an even denser blue filter from the series 80 conversion filters.

Since sky conditions vary greatly these filters might not always fully correct the color but will give good results.

LIGHT-BALANCING FILTERS

Daylight Sources	Filtration for EKTACHROME 160 (Tungsten) Film (3200 K)	Filtration for KODAK Films (5500 K)
Sunrise, sunset	82 (blue)	80B or 80C (blue)
2 hours after sunrise or before sunset	81 + 81EF (yellow)	80D (blue)
Mean noon sunlight	85B (orange)	None
Overcast sky	85B (orange) + 81B	81A or 81B (amber)
Open Shade	85B + 81A	81B or 81C (amber)

A more common problem is excessive bluishness from overcast days and open shade. Pictures taken on slide film on an overcast day usually show a slight blue tinge and a stronger blue tinge if the picture was taken in open shade on a clear day. A blue tinge may not be objectionable unless a face is prominent in the picture. Few people find blue-tinged faces appealing. With negative films, there's little need for filtration as the photofinisher can eliminate the bluishness during printing. With slide films, you can eliminate the bluishness with one of the yellowish 81 series filters. An 81A or an 81B filter is a good all-around choice that works well both on overcast days and in open shade. To eliminate the stronger bluishness of open shade on very clear days, try an 81C filter. It will render flesh tones nearly normal. A skylight filter is often recommended to reduce bluishness, but it gives only a very slight improvement.

The yellowish 81 filters can also be used for landscape photography on overcast days. However, don't be haphazard about using them. Days of snow and rain really are bluish. Eliminate that bluishness, and you risk reducing the moodiness of a storm photograph. High altitudes and snow-covered fields are other locations with an abundance of blue light. Shadows on snow look bluish when unfiltered. To some people bluish shadows are appropriate in a snow scene. To others it's just too much blue. Some electronic flashes also discharge excessive blue light. Most flashes have a built-in filter or a golden reflector to reduce any bluishness. If your flash pictures appear too blue, fasten one of the 81 series filters to your lens during flash picture-taking.

If you're taking a picture of somebody standing under a leafy green tree, the light filtering through the green leaves tints your subject green.

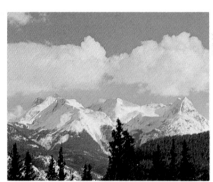

A filter from the 81 series of filters can lessen the bluishness. A No. 81B filter was used here.

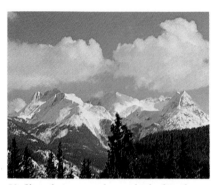

Unfiltered pictures taken at high altitudes may appear too bluish from the abundance of blue light.

The simplest solution is to move the person to another area, but if you can't move the subject, a CC10M or CC20M filter should counteract the green. Colored walls also reflect their colors onto subjects. Keep these things in mind when color balance is critical.

When taking pictures on the beach or in the rain, you can use a skylight or ultraviolet filter to protect the lens from sand and water spray. If you're a bit rough on your equipment it might be a good idea to leave a skylight filter on the lens at all times. In cost, a filter pales when compared with a lens. Purists might argue that any extra surface, including a skylight filter, risks slight (probably undetectable) changes in color and image quality. They're right. If you're a purist by all means don't use the skylight filter just to protect your lens. If you aren't, use it.

CONVERSION FILTERS

Filters that give a photograph proper colors when you use a film with the wrong light source are called conversion filters. If you shoot daylight film, such as KODACHROME 64, in tungsten lighting, the pictures turn out yellow-red. If you shoot tungsten film, such as KODAK EKTACHROME 160 Film, in daylight, the pictures turn out bluish. A conversion filter restores the proper colors. It does so by changing the color balance of the light to the proportions of red, green, and blue needed by the film for correct color rendition. In effect, a daylight conversion filter changes tungsten light into daylight, and a tungsten light conversion filter changes daylight into tungsten light.

Conversion filters come in two series. Dark yellow, series 85 filters convert tungsten film for daylight use. Dark blue, series 80 filters convert daylight film for tungsten light. Each series contains several filters for controlling many color nuances. Some of the color nuances can be

When used without a conversion filter in tungsten lighting, color daylight film shows a yellow-red cast.

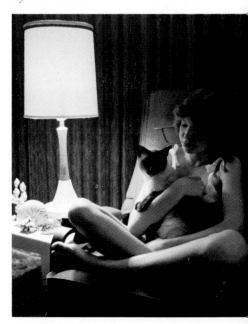

found in tungsten lighting. For instance, a 75-watt tungsten bulb is slightly more yellow-red than a 100-watt bulb which is slightly more yellow-red than a photolamp. Usually you can get by with just two conversion filters: A No. 80A (dark blue) for using daylight film in tungsten light and a No. 85B (yellowish orange) for using tungsten film in daylight.

As you can see from the accompanying pictures, the conversion filters do a good job. What you can't see is that the No. 80A filter for use with daylight films under tungsten lighting requires a 2-stop increase in exposure. That can be a problem. About the only place you'll use this filter is indoors where the light is already dim. Subtract that 2-stop loss from the dim light, and you'll probably have an unacceptably slow shutter speed even with high-speed daylight film. One solution is to use EXTACHROME 160 Film (Tungsten) which can be rated at ISO (ASA) 160 or at ISO (ASA) 320 with push-pro-

A No. 80A conversion filter blocks the excessive yellow-red light to give more normal colors to pictures taken with daylight film under tungsten lighting.

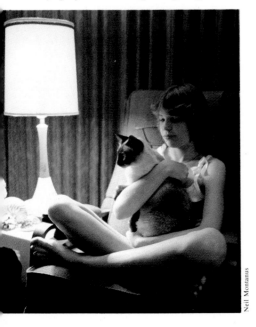

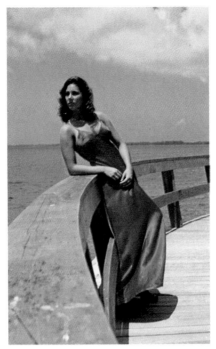

A No. 85B conversion filter restores normal colors to tungsten film used outdoors.

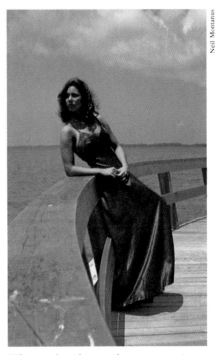

When used outdoors without a conversion filter, tungsten-balanced film shows a bluish cast.

cessing. Used indoors, it gives you the speed you need. Used outdoors, with a No. 85B filter, you lose only 2/3 of a stop to the filter factor. Ideally, you should avoid mismatching film type and light source. Keep a roll or two of EKTACHROME 160 Film (Tungsten) handy for when you'll need it. The table shows the appropriate filters for

Kodak color films when used with tungsten or photolamp lighting.

Should you ever be caught without the correct film or filtration, use a high-speed color negative film such as KODACOLOR VR 400 or VR 1000. These films are color balanced to give better results under tungsten lighting than normal color negative films.

CONVERSION FILTERS FOR *KODAK* COLOR FILMS

KODAK Color Films	*Balanced for*	Daylight	Photolamp (3400 K)	Tungsten (3200 K)
KODACOLOR VR 100 KODACOLOR VR 200 KODACOLOR VR 400 KODACOLOR VR 1000	Daylight, blue flash or electronic flash	No filter	No. 80B	No. 80A
KODACHROME 40 5070 (Type A)	Photolamps (3400 K)	No. 85	No Filter	No. 82A
KODACHROME 25 KODACHROME 64 EKTACHROME 100 EKTACHROME 200 EKTACHROME 400 EKTACHROME P800/1600	Daylight, blue flash, or electronic flash	No filter	No. 80B	No. 80A
EKTACHROME 160 (Tungsten)	Tungsten (3200 K)	No. 85B	No. 81A	No filter

COLOR COMPENSATING FILTERS

When it comes to fluorescent lighting, color compensating (CC) filters can improve the colors in your pictures. Although there's a daylight film for daylight and a tungsten film for tungsten light, there's no such thing as a fluorescent film for fluorescent light. But there are filters. Filters are needed because fluorescent lights do not give off equal amounts of red, green, and blue light. Most are deficient in red light. This means that pictures taken with daylight film will be greenish and pictures taken with tungsten film will be bluish.

Fortunately, the remedy to these color casts is simple. Use a CC30M filter, which is a color compensating filter. It serves as an all-purpose fluorescent filter for color daylight film. It won't give perfect results, but it will help. If you want the best color possible, match the filtration to the type of tube. Also use daylight film. With fluorescent lighting, it gives better colors than tungsten film. Once you determine the type of tube, use the table on the next page to select your filters. If color balance is critical, first make trial pictures to see if the chosen filtration suffices. The trial is necessary because color is affected by many factors including voltage, tube age, diffusers, lenses, and film emulsion.

Two screw-in filters also help correct daylight and tungsten film for

Under fluorescent lights, unfiltered daylight film reveals a distinct and unpleasant greenish cast.

Filtration with color compensating filters gives normal colors. If you don't have a filter, use color negative film. It can be corrected during printing to give acceptable results.

Derek Doeffinger

cool white fluorescent lights, the most widely used fluorescent lights. The filter that corrects fluorescent light for daylight film is typically designated FLD (fluorescent daylight). The filter for tungsten film is an FLT or FLB (fluorescent tungsten). Each of these filters requires a one-stop increase in exposure.

Should you be without the correct filtration, use color-negative film. The colors in prints will be much closer to normal than the color in slides. You can always have color slides made from the negatives. Color compensating filters can be used

creatively as you'll see in the following section. They are also good for underwater photography, where the color quality of light underwater varies with depth, water quality, and incoming light. General filter recommendations won't help much with so many variables but for shallow, clear water a CC30R works best.

Made of gelatin, color compensating filters are available in the three primary colors—red, green, blue—and the three secondary colors—cyan, magenta, yellow. A typical designation for one of these filters is CC20Y. The CC stands for color compensating, the 20 stands for a density of 0.20 (to blue light in this instance) and the Y for yellow. KODAK Color Compensating Filters are made in the following densities: 0.025 (CC025), 0.05 (CC05), 0.075 (CC075), 0.10 (CC10), 0.20 (CC20), 0.30 (CC30), 0.40 (CC40), and 0.50

Color-compensating filters range from the wisp of color in the CC05M filter on the left to the dense coloration in a CC50M filter on the right.

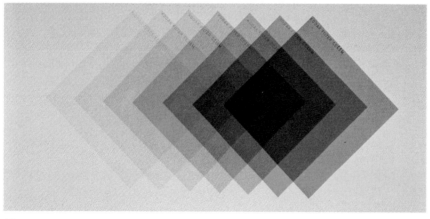

(CC50). You can sandwich as many as three filters together without noticeable loss of image quality.

Color compensating filters mainly control the primary colors. Each filter in a primary color attenuates the remaining two primary colors. A red color compensating filter, for example, reduces green and blue light. A filter of one of the secondary colors, affects the primary complement. Thus a yellow filter reduces blue light, a magenta filter reduces green light, and a cyan filter reduces red light. How much the light is reduced depends on the filter's density.

CC filters can also help to compensate for peculiar light absorptions, such as in taking pictures through tinted glass. Use a filter that is a complement to the tint. For example, with green glass, use a magenta filter.

The chart on this page gives filtration that approximately balances the color of various fluorescent light sources and high-intensity discharge lamps to the color of light required by Kodak daylight and tungsten films. With the indicated filtration, the reproduction of colors from a scene will be similar to the same colors viewed under white light.

FILTER STARTING POINTS WITH FLUORESCENT AND HIGH-INTENSITY DISCHARGE LAMPS FOR *KODAK* COLOR FILMS

Type of lamp	Films with daylight balance		Films with 3200K tungsten balance
			Type B and Type L
	KODACOLOR VR 100 **KODACOLOR VR 200** **KODACOLOR VR 400** **KODACOLOR VR 1000** **EKTACHROME 100** **EKTACHROME 200** **VERICOLOR III** **Professional, Type S**	**KODACHROME 64** **EKTACHROME 64** **EKTACHROME 400** **EKTACHROME P800/1600 Professional**	**EKTACHROME 160** **EKTACHROME 160 Professional** **EKTACHROME 50 Professional** **EKTACHROME Professional 6118** **VERICOLOR II Professional, Type L**
Fluorescent			
Daylight	40M + 40Y + 1 stop	50M + 50Y + $1\frac{1}{3}$ stop	85B + 40M + 30Y $1\frac{2}{3}$ stop
White	20C + 30M + 1 stop	40M + $\frac{2}{3}$ stop	60M + 50Y + $1\frac{2}{3}$ stops
Warm White	40C + 40M + $1\frac{1}{3}$ stops	20C + 40M + 1 stop	50M + 40Y + 1 stop
Warm White Deluxe	60C + 30M + 2 stops	60C + 30M + 2 stops	10M + 10Y + $\frac{2}{3}$ stop
Cool White	30M + $\frac{2}{3}$ stop	40M + 10Y + 1 stop	60R + $1\frac{2}{3}$ stops
Cool White Deluxe	20C + 10M + $\frac{2}{3}$ stop	20C + 10M + $\frac{2}{3}$ stop	20M + 40Y + $\frac{2}{3}$ stop
Unidentified	10C + 20M + $\frac{2}{3}$ stop	30M + $\frac{2}{3}$ stop	50M + 50Y + $1\frac{1}{3}$ stops
High-Intensity Discharge			
General Electric LUCALOX	70B + 50C + 3 stops	80B + 20C + CC80B + $2\frac{1}{3}$ stops	50M + 20C + 1 stop
General Electric MULTI-VAPOR	30M + 10Y + 1 stop	40M + 20Y + 1 stop	60R + 20Y + $1\frac{2}{3}$ stops
Deluxe White Mercury	40M + 20Y + 1 stop	60M + 30Y + $1\frac{1}{3}$ stops	70R + 10Y + $1\frac{2}{3}$ stops
Clear Mercury	50R + 30M + 30Y + 2 stops	50R + 20M + 20Y + $1\frac{2}{3}$ stops*	90R + 40Y + 2 stops

Notes: Red or blue filters are recommended in some cases to limit the total number of filters required to three.

*For EKTACHROME 400 Film use 25M + 40Y filtration and increase exposure 1 stop.

Creative color filtering

We feel blue. We see red. Turn green. Act yellow. And are in the pink. For nearly every emotional and physical state we experience, there's a corresponding color that describes it. One color can represent many moods. Red, for instance, can symbolize both anger and passion. Blue can indicate both sadness and serenity. Not only are colors equated with emotions, they have a part in creating them. Red excites. Blue calms. Can you imagine listening to the whining drill of a dentist with fiery red walls confronting you or a bullfighter taunting his snorting opponent with a baby-blue cape?

If frontlighted, the picture to the right might well have appeared contrived. However, the streaming backlighting and the striking pose instill this figure with a mysterious energy. In the bottom picture on this page, a tiny but brilliant and colorless sun balances the massive silhouettes and the great expanse of magenta sky.

Ken Biggs

48

Robert Llewellyn

MOOD THROUGH COLOR

The influence and pervasiveness of color in our lives can't be overestimated. Nor can the influence of color in photographs be overestimated. By manipulating the colors of a photograph, you can manipulate the reactions to it. A cabin buried in snow seems much colder when pictured in blue than in red. A scene at midday seems like evening when photographed with a yellow filter and like a moonlit night when photographed through a blue filter and underexposed.

The effects of color filtration can be subtle or obvious. It all depends on the filter you use. With a CC1OG filter you can enhance the greens of a forest scene so subtly that only you would know that a filter was used. However, a No. 25 red filter used to give a sultry look in a portrait would be obvious to everyone.

Choosing a filter to fit the subject is a lot like coordinating clothes. Just as a shirt and jacket should complement each other so should a filter and its subject. Filter selection should not be arbitrary. Something about the subject should suggest to you the type (if any) of filtration that would reinforce what you want to say. For instance, the choice filter for an oxen-drawn plow would probably be a sepia filter, which would heighten the sense of antiquity of this plowing. The choice

Paul Kuzniar

© 1981 Bill Carter

Neil Montanus

Quite startling is the sight of an alluring woman dressed in an elegant evening gown and waiting in a cavern. The blue filter creates a sensation similar to waking from a dream so real that it couldn't have been a dream. The antiquity of Cairo, **top,** *grows even greater when photographed through an orange split-field filter. Seemingly a bizarre choice, a magenta filter,* **above,** *adds a surrealism equal to the grace of the swan.*

Ken Biggs

Blue and red filters create opposite effects on the same scene. The blue calms with the sleepy tranquility of a moonlit night in a forest. The red rages like a rampaging wildfire. In the bottom photo a yellow filter accents sunlight streaming through a forest.

filter for a blacksmith hunched over a glowing shoe would probably be red, to heighten the heat and strength needed to bend the shoe. Of course, the standard filter for a sunset would be red, but what would a sunset in green look like? Surrealistic, to say the least. Through purposeful selection of a seemingly inappropriate color filter you can concoct some pretty outlandish images. Such departure from reality can be either bizarre or surprisingly fitting.

Far out filtration doesn't always work. But it does expand your experience. Experiment. It's a good way to learn. Instead of trying to imagine what the results look like, you have them to study. It cuts down on future guesswork and eventually, as you gain experience, gives you a deft touch in filtering your subjects.

FILM SELECTION

To get color effects representative of the colors reaching the film, use slide film. The colors it records during exposure are the colors you will see after processing. The photofinisher does not affect it. Just the opposite is true with color negative film. With it, the photofinisher has to judge what the colors should be when the negatives are printed. Almost always, normal colors are aimed for. Just what you don't want. If you do your own color enlarging, then negative film will be no obstacle. If you don't do your own color enlarging, and still want to use negative film, inform your photofinisher of the filtration used and hope for the best. Unless your photofinisher does custom work, he probably can't afford to give your pictures special treatment.

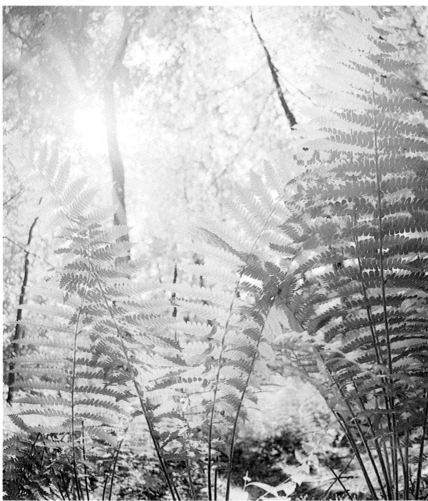

Robert Llewellyn

51

DARK-COLORED FILTERS

Dark-colored filters, such as a No. 25 red and a No. 47 blue, affect a subject quite differently than light-colored filters. Dark-colored filters produce monochromatic pictures. A single deep color engulfs the photograph, masking out all other colors. Subtleties of shade and color vanish. Details disappear. It's a good idea to bracket when using dark-colored filters creatively. Bracketing is suggested because with dark filters the so-called "correct" exposure may not look best. Creatively, an underexposed or overexposed photo may look better.

The dull gray of an overcast sky can be enlivened with a filter.

Derek Doeffinger

© 1981 Bill Carter

To create a moonlight effect with the sun, use a blue filter and underexpose by 1 or 2 stops.

OVERCAST DAYS

The dull gray of an overcast sky looks good in a picture only if you're trying to show the dull gray of an overcast sky. Filter buffs need little encouragement. Overcast skies are signal enough that it's time to pull out the filters and do a little experimenting. Try shooting the same subject with several different filters. Try varying the exposures to see if you like the results from some filters better underexposed, overexposed, or correctly exposed

MAKING SILHOUETTES

Dark-colored filters absorb nearly all light from dissimilarly colored objects and transmit colors closely related to the filter color. Unless you purposely want to tone down detail, the best subjects for dark-colored filters show bold lines and shapes in simple patterns and with little detail. For example, a city skyline or mountain peaks carry bold, simple shapes.

Such subjects can be further simplified by using a silhouette or the opposite of a silhouette which would be a bright form against a dark background (a sun-reflecting river flowing through a dark canyon).

To make a silhouette first requires a bright background. The sky is the most common bright background. A white wall, sun-reflecting water, a bonfire, and other bright sources work as well. Now you must underexpose by 2 or 3 stops to darken the subject and make a silhouette out of it. Underexposure also helps when you are photographing a highlight against a dark background. Suppression of detail through underexposure creates bold poster-like pictures.

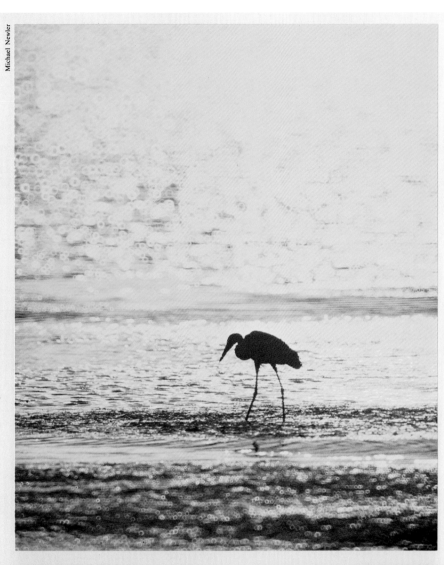

Michael Newler

By exposing for the sun's reflection on the water, a silhouette of the heron was created.

Silhouetting simplifies a busy construction site, emphasizing the forms of the workers and the steaming vapors.

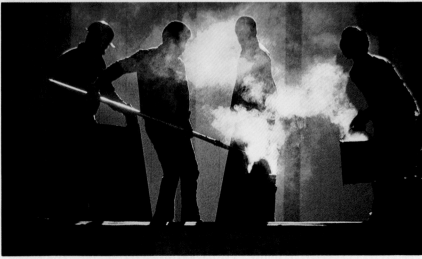

Robert Llewellyn

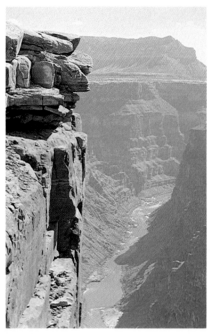

No filter

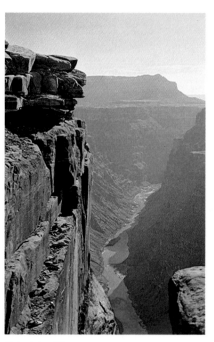

Polarizing filter

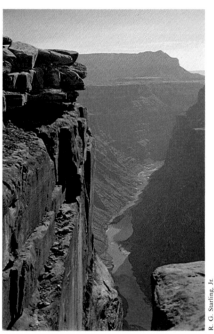

Polarizing filter and CC20M filter

R. G. Starling, Jr.
Lingstar Cinegraphic

To improve the color of the canyon walls, the photographer first used a polarizing filter and then added a CC20M filter to the polarizing filter for an even richer yet natural color.

LIGHT-COLORED FILTERS

Like dark-colored filters, light-colored filters also work well with silhouettes and other graphic subjects. Because the color is less intense, the result is quieter, not quite so attention-grabbing.

KODAK Color Compensating Filters offer you a range of color densities from very light to medium. A CC10Y filter presents a barely perceptible yellow coloration in a picture. The color from a CC40Y filter is quite noticeable. Pastel filters in orange, violet, green, and other colors are just as effective and are available from several filter manufacturers. Light-colored filters usually require less than a stop increase in exposure. They block only a portion of the colors dissimilar to the filter so that a wide range of colors can still be rendered.

Light-colored filters are ideal for work with detailed scenes. You can maintain the detail but shift about the emphasis as you please. For instance, a landscape of a wheat field on an overcast day would be bluish, a color that directs attention towards the weather in the picture. With a CC10Y or a CC20Y filter, you can make the wheat field golden as it should be, and shift the emphasis from the weather back to the wheat. The final picture would not even look filtered. A similar result can be obtained by using a CC20G filter on a forest or a CC20M filter on a swamp. Simply match the color of the filter to the color of the subject you want to enhance.

SUNRISES AND SUNSETS

Pictures of brilliant sunsets have become so common that they should seem trite. Somehow they manage to elude triteness. If you like filtered sunsets by all means shoot them. But don't ignore the possibilities of an unfiltered sunset. To get the best exposure, with the filter attached, meter the sky area next to but excluding the sun. If you meter with the sun included, the picture will be grossly underexposed. Bracket your basic exposure by 1 stop to be sure of getting a good exposure. Underexposure will render rich, saturated colors in the sky.

Sunsets are seldom as bright as they seem. When shot with a deep-colored filter or slow- or medium-speed film you may need a tripod, especially if you're using a telephoto lens. The alternative is to use a high-speed film.

Is the sunset on the right filtered or not? The answer is no. These are the natural colors. If such strong coloration had not been present, the photographer could have added them with a magenta filter. An orange filter added the intense orange to this sunset, **below.**

Bob Kretzer

Derek Doeffinger

COLOR POLARIZING FILTERS

Color polarizing filters economically bridge the wide range of filters needed to cover all the shades from light to dark in many colors. One filter can do the job of many. Color polarizing filters are available in single-color and bicolor models. The same filter that adds a blush of red to a portrait can also give a touch of green to a forest study. Red-blue, orange-green, and green-purple are a few of the bicolor filters.

With the color polarizer fastened, you rotate the front element until you see the color you prefer. Single color models can be varied from a very pale hue to a heavy saturation. Bicolor models produce less variation in color saturation, but you can dial varying intermediate colors that are blends of the two basic colors. For example, with a red-blue color polarizer, you can produce a magenta hue by rotating the outer element to a point between the maximum red and blue ends of the scale.

A color polarizing filter may have a built-in polarizing filter or you may have to attach a separate polarizing filter. Since one component is a conventional polarizer, you can also create unusual effects when photographing reflections. With a red-blue unit, it's possible to make pink highlights on blue water.

At their maximum settings, color polarizers greatly reduce the incoming light. Unless you're photographing on a bright day, you may need a fast daylight film such as EKTACHROME 200 or EKTACHROME 400 Film or a tripod. Beware of vignetting when using bicolor polarizers with wide-angle lenses. Many of the bicolor polarizers are long enough that their front ends stick into the view of a wide-angle lens.

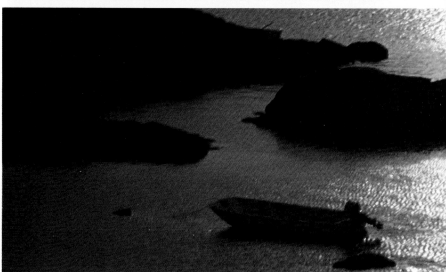

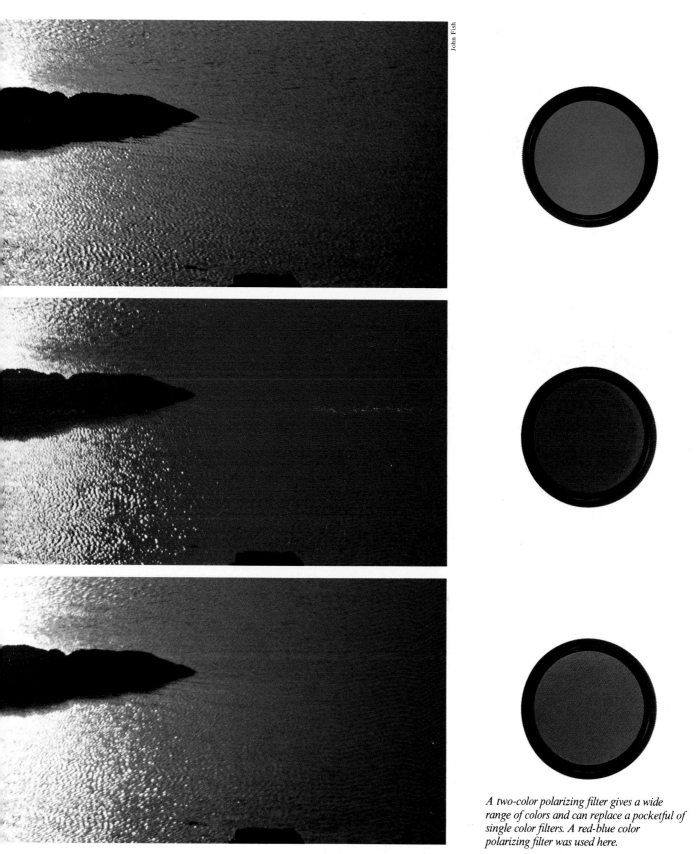

John Fish

A two-color polarizing filter gives a wide range of colors and can replace a pocketful of single color filters. A red-blue color polarizing filter was used here.

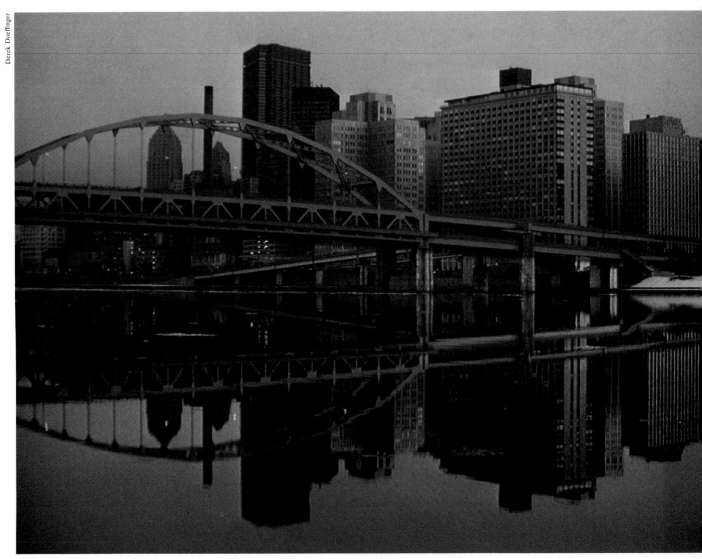

Derek Doeffinger

GRADUATED FILTERS

With graduated filters you can nimbly walk the tightrope between reality and illusion. They allow some of the most sophisticated and effective filtration possible. Graduated filters are colored on one half of the filter. The other half is clear. The color density lessens as it nears the clear half to produce a blending effect. On many graduated filters, a small post on the inside edge of the rim lets you rotate the filter. Align the bottom edge of the colored half with a horizon or other distinct line in the scene to hide the change from colored to clear area.

The clear portion of the filter sets up the whole effect. It shows reality, colors as they actually are. When the eye sees and recognizes true colors in a picture it expects the remaining colors to also be true and usually dupes the brain into thinking they are. In reality, however, the other half of the scene is falsely colored. Graduated filters seldom strain the effect because the colors are not wild. Tobacco, mauve, blue, and gray are some of the colors used. Most often they are used to change sky colors while preserving land colors. A neutral density (gray) or a colored graduated filter can be used either to

reduce or increase contrast. For instance, by aligning the neutral density half to the sky at sunset you can show detail in the land without overexposing the sky. You can also fake a stormy sky by darkening a drab overcast sky. You can even use a neutral density graduated filter with flash to tone down the foreground which is typically brighter due to flash falloff. When well done, the result is a flash picture with nearly even brightness throughout.

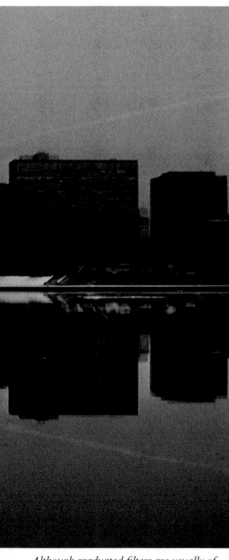

Although graduated filters are usually of more subtle coloration, an orange one was used here to contrast the skyline with its reflection in the water.

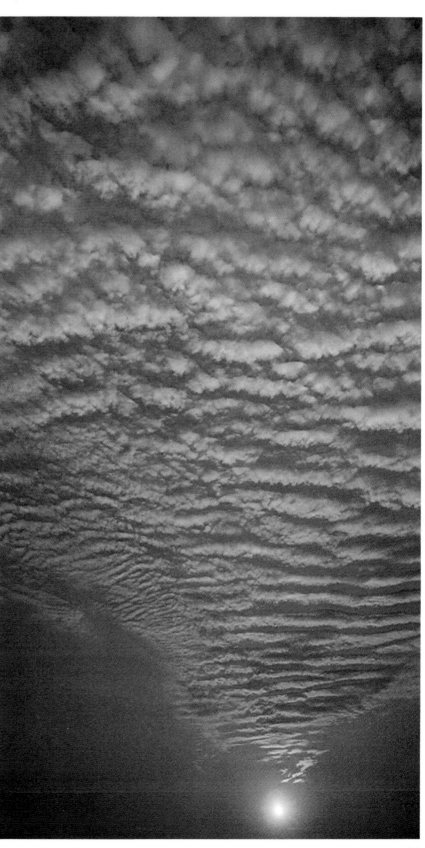

© 1981 Anthony Boccaccio

The photographer simulated a fiery sunset by using an orange graduated filter over the sky near the sun.

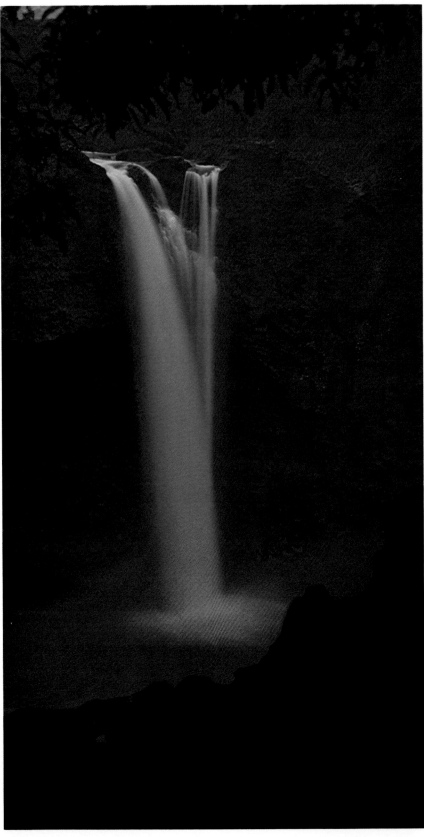

Ken Biggs

SPLIT-FIELD FILTERS

Split-field filters resemble graduated filters. The main difference is that the colored half of the filter has the same density throughout. There is no lessening of density to blend in with the clear half. Some split-field filters also have two colored halves instead of a colorless half and a colored half. They also feature more garish colors, such as orange, green, red, magenta. Capable of being used quite effectively, these colors quickly tip the viewer that a filter was used. They don't carry the realism of graduated filters. However, they perform well for brash effects. An orange split-field filter can intensify the orange sky at sunset while not changing the color of the land or water. Graduated and split-field filters offer endless uses. Their effects are strong. To learn how to make your own split-field filters, see the chapter, "Making Your Own Filters."

This stunning waterfall was photographed through a red-blue split-field filter using a slow shutter speed to blur the cascade of water. What seems to be a spotlight on the pool of water isn't. The spotlight effect results from overexposure through the red filter which is less dense than the blue filter.

EXPOSURE WITH GRADUATED AND SPLIT-FIELD FILTERS

When using a split-field or graduated filter that has a clear half, determine the exposure before you attach the filter. If you determine exposure after attaching the filter, the meter will indicate an exposure increase. When using split-field and graduated filters, you'll usually want to camouflage the clear-color border by aligning it to a horizon or some other naturally occurring line in the scene. Otherwise you may lose the effect. Also avoid using a small aperture with a wide-angle lens or the clear-color border might show up as a fuzzy line in the picture.

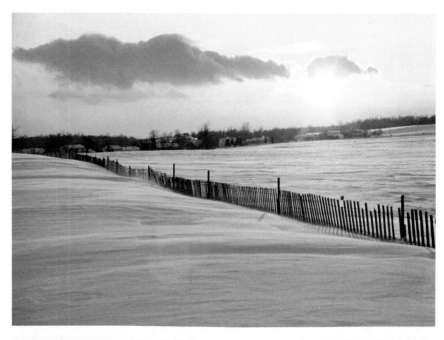

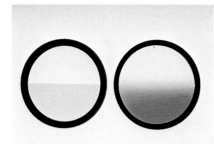

Split-field filter *Graduated filter*

A split-field filter has a sharp color cut off and a graduated filter has a gradual color cut off.

By exposing for detail in the foreground, the photographer overexposed the sky in the top photo. By using a graduated or a split-field filter you can darken the sky and preserve detail in the foreground as in the bottom photo.

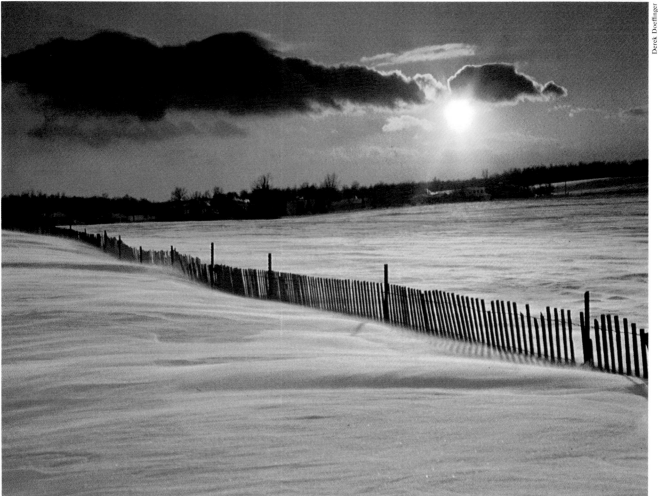

Derek Doeffinger

MULTIPLE EXPOSURES

You can put additive color theory to practice and make some intriguing pictures that are both normally and abnormally colored. Here's how. Put your camera on a tripod and make three exposures on the same frame of film. Make the first exposure through a No. 25 red filter, the second exposure through a No. 61 deep green filter, and the third exposure through a No. 38A blue filter.

To determine the exposure, take a meter reading of the scene without a filter attached. Then increase the exposure that the meter indicates by one stop for each of the three exposures. For example, normal exposure for a sunlit scene with KODACOLOR VR 100 Film is 1/125 second at $f/16$, which means you would use 1/125 second at $f/11$ for the exposure through each of the three filters. Select a subject that has some movement, such as a seascape or a landscape on a windy day, to get the rainbow of color in the highlight areas of your picture.

You can also photograph action with this multiple-filter technique with a homemade shutter. Page 90 of the chapter, "Making Your Own Filters," gives all of the details on assembling a special shutter made of a three-filter strip mounted in cardboard.

Negative films, such as KODACOLOR VR 100 or KODACOLOR VR 400, are easy to work with when you're trying multiple exposures because they have more exposure latitude. You can always ask your photo dealer to have slides made from your processed negatives if you would rather have slides than prints.

Some 35 mm cameras have a multiple exposure control for making multiple exposures (usually a small lever adjacent to the film advance lever). If your camera lacks such a device, you can still make multiple exposures. After making the first exposure, hold in the rewind button on

the bottom of the camera while also holding the rewind knob atop the camera immobile. Now cock the film advance lever. Take the next exposure and repeat this maneuver with the camera controls. It is likely that the three exposures won't be perfectly registered. Don't force any camera controls if they seem to resist this procedure.

To make this picture the photographer waited several minutes between exposures to allow the shadows to move.

Raymond Pojman

Raymond Pojman

Colors ebb and flow and blend together to show the rhythm of the tide.

A triple exposure, alternately made through red, green, and blue filters adds color only to the billowing smoke. The slight misregistration of the image is typical of multiple exposures made with 35 mm cameras. For fast moving subjects, you can use a Harris Shutter. See page 90.

Derek Doeffinger

HOW IT WORKS

How are normal colors produced when photographed through three filters? Think back to the first chapter on color. Red, green, and blue light combine to form white light. White light (daylight) strikes objects. These objects take on color by selectively reflecting and absorbing the different colors in white light. By alternately using red, green, and blue filters in the same picture, all colors of light from a scene are eventually passed and accumulate to give a normal appearance. But the appearance is only normal for stationary objects. Moving objects are in a different position at each filtering stage. Thus they reflect red light in one position, blue light in another position, and green in still yet another position. The cumulative effect never takes place. Instead, the red, green, and blue filters show the track of the moving object.

John Phelps

Only without filtration can the soft, muted colors and lighting of this twilight scene be captured.

TO FILTER OR NOT TO FILTER

Don't get into the habit of automatically slapping on a filter just because you're photographing a sunset. Many sunsets and other traditionally filtered subjects look best unfiltered. The subtle gradation of color and light in the sky, the mirrored clouds in the water are just a few of the precious things that might fall before reckless filtering. Although the solution is as easy as shooting the same scene with and without a filter, you're treating the symptom not the source. Any subject worth photographing is worth thinking about. Just as you carefully consider composition and viewpoint so should you weigh the usefulness of filtration. If it helps the picture, use it. If not, don't use it.

FORTIFIED FILTRATION

When you choose creative filtration to change a scene, you are saying that the scene you see is not the scene you want. Through filtration you hope to alter the mood of a scene. Don't always expect mere filtration to transform a scene. Use viewpoint, composition, lighting, and lens selection to bolster the effect of the filter. Study the pictures on the opposite page to see how such factors strengthen the filtration.

Towering pines, misty twilight, an arc of highway, and headlights synthesize a strong image.

Ken Biggs used a fish-eye lens to distort the water and tilted the camera so the water seems to flow out of the picture.

Ken Biggs

Robert Llewellyn

Massive sundial? Ritual altar? Of unknown purpose, the mystery of Stonehenge megaliths increases when a wide-angle lens creates a swirling storm and makes the monument loom out of the picture.

65

Filters with flash

More and more electronic flash manufacturers offer filters as an accessory to their flash units. Flash gives you flexibility: you can control the direction and intensity of the light. By simply moving the flash a few feet you can change from sidelighting to backlighting to frontlighting. You can also add several colors from several directions by using filters with multiple flash. When working with a single flash, you can place the filter over the flash or over the lens. By placing the filter over the flash you color only the area struck by light from the flash. A background beyond the range of the flash is colored normally. By placing the filter over the lens, everything is tinted the color of the filter.

Two flash units were used to make this picture. The unit behind the model had a yellow filter over it. The unit in front of her had a snoot on it so only a small portion of her face would be lighted.

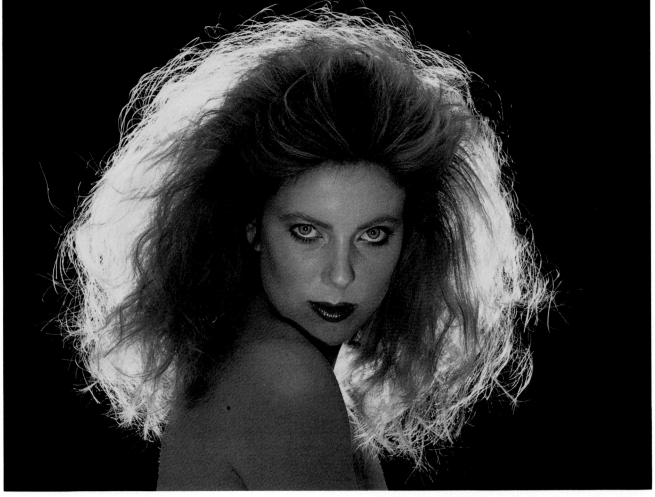

Neil Montanus

EXPOSURE WITH FLASH

Theoretically, determining exposure for filtered flash depends on several factors: flash power, filter density, subject distance, subject color, film exposure, flash type, and even the effect you want. Determining exposure hinges on so many factors that filtered flash seems nigh impossible. It isn't. You're saved by one important consideration. A variety of exposures usually look good with filtered flash. You're trying for a theatrical effect, and you get it with a variety of exposures.

The best place to start is with your camera and flash manuals. Check them for any specific instructions about using filters with flash. If they have them, follow them. If they don't, try this trial-and-error method. To determine exposure make your own tests. Start out by setting the film speed on your flash. Select the aperture indicated by the flash. Place the filter over the lens or flash. Take a few shots at this aperture. The results will often be slightly underexposed yet look quite good. Next open up a stop and take a few shots. These should also look good. If you close down a stop beyond the flash recommendation, the pictures will probably be too underexposed. But as long as you're making a test roll, try a few shots at one stop less than that indicated by the flash calculator dial. When your test roll returns, examine it. Compare the results you like with the exposures used.

In the future, you'll probably still want to bracket when using filters with flash. It's a safeguard. There are a lot of variables and until you're comfortable with them don't risk losing some good shots because of poor exposure.

When using a filter with electronic flash, open up the lens aperture according to the filter factor, and then bracket exposures.

If you don't have a filter kit for your flash, you can tape a gelatin or plastic filter over the flash head. You can also use a filter over the lens when using flash.

John Menihan

USING COMPLEMENTARY FILTERS

By using complementary filters over flash and lens you can take photos that show a normally colored foreground and an abnormally colored background. It's not an easy technique and it requires some fiddling around, but if you want to try it, here's how it works. When you photograph a scene through a magenta filter, the entire scene is rendered magenta. But if you photograph part of that same scene with a magenta filter over the lens and a green filter over the flash, that part of the scene struck by light from the flash is normally colored. In effect, the green light from the filtered flash neutralizes the magenta filter on the camera. The green light from the flash does not reach the background. Thus the magenta camera filter renders the background magenta. The area struck by light from the filtered flash always has normal coloration. The remaining areas are always tinted by the color of the filter on the camera.

Color negative film is easier to work with because it has more exposure latitude than slide film. Avoid high-speed films when using 35 mm SLR cameras because with the relatively slow flash synch shutter speed, you'll often be faced with using small apertures. Only very powerful flash units can accommodate small apertures. You'll need a fairly powerful flash or two flash units firing together. An extension cord for your flash will let you adjust flash to subject distances. Any complementary set of KODAK Color Compensating Filters of sufficient density should work. The complementary pairs are magenta—green, red—cyan, and yellow—blue. Use CC50 or above filters to obtain sufficient coloration. You can add two filters together to increase the density.

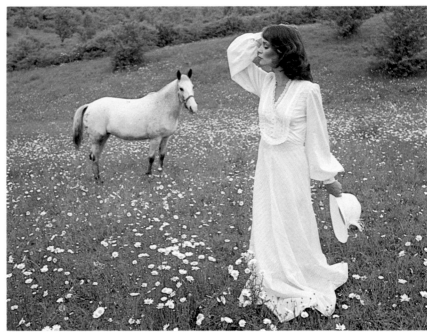

Here's the scene without any filters.

COMPLEMENTARY FILTERS BASIC PROCEDURE

The complementary filter effect works best with a background of medium or low brightness, such as an overcast sky. Use the following procedure:

1. Set the shutter to the flash synch speed.
2. Without the lens filter attached, determine the exposure for the scene. Open the lens aperture according to column two in the table below.
3. Fasten complementary filters to the lens and the flash.
4. Set the flash on manual. Set the film speed on the flash.
5. On the flash calculator scale, find the distance corresponding to the lens aperture.
6. Divide that distance by the flash factor in column three of the table below. This new distance is your flash-to-subject distance.
7. Bracket exposure.

Density of CC filters	Open the lens	Flash factor
CC50	1 stop	2
CC60	1½ stops	3
CC70	1½ stops	3
CC80	2 stops	4
CC90	2 stops	4

Example: A CC50M over the lens and a CC50G filter over the flash.

The shutter speed is the flash shutter speed. Without the CC50M filter attached, the meter indicates an aperture of $f/11$. According to the table, you should open up the lens 1 stop for a CC50 filter. Set the lens at $f/8$, since it is one stop wider than $f/11$.

On the flash calculator scale, the distance corresponding to $f/8$ is 10 feet. According to the table, the flash factor for filtration of CC50 is 2. 10 feet divided by 2 (the flash factor) is 5 feet. 5 feet is the flash-to-subject distance.

USING A GUIDE NUMBER

If you're a guide number user, try this formula with complementary filters:

$$\text{Flash-to-subject distance (feet)} = \frac{\text{Guide No. (feet)}}{\text{Adjusted aperture}} \times \frac{1}{X}$$

where X is the increase in the number of stops in the far right column of the adjacent table. To find the adjusted aperture, determine the correct existing-light aperture (with shutter set at a flash synch speed) using your meter, and then open the aperture as recommended in column two of the table.

*By using complementary filters, such as CC80M filtration over the lens and CC80G over the flash, you obtain normal coloration in the foreground where light from the filtered flash is counteracted by the lens filter, **top.** However, the background shows the same color as the lens filter because light from the flash does not reach that far. By using a filter over the flash only, **bottom,** the foreground is colored and the background remains normal.*

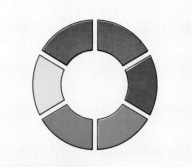

COMPLEMENTARY FILTERS

Colors opposing each other in the circle above represent the complementary colors: red—cyan, blue—yellow, and green—magenta. Fasten one filter to the lens. Attach a filter of the complementary color and of equal density over the flash.

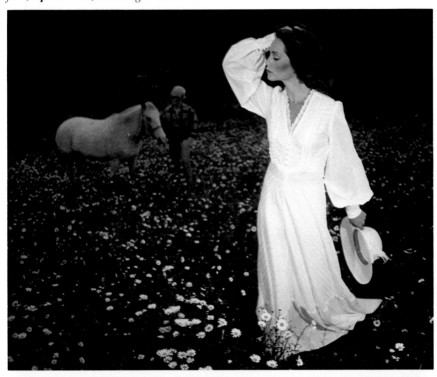

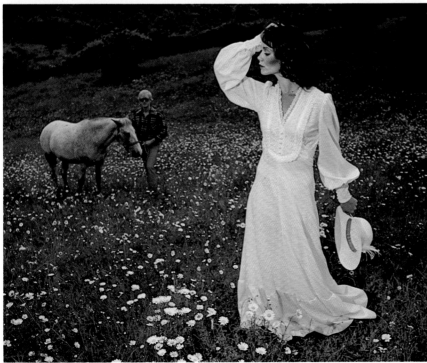

Neil Montanus

Special-effects filters

All your experience with color filters won't quite prepare you for some of the far-out effects possible when you use an attachment that bends the light instead of absorbing it. Special-effects filters can cause light from a beacon or any other light source to radiate a two-point, four-point, eight-point, or sixteen-point star. They can produce a multicolored streak of light or a rainbow. Your picture can even rain color with the right attachment.

A star filter adds radiating lines of light to any bright light source.

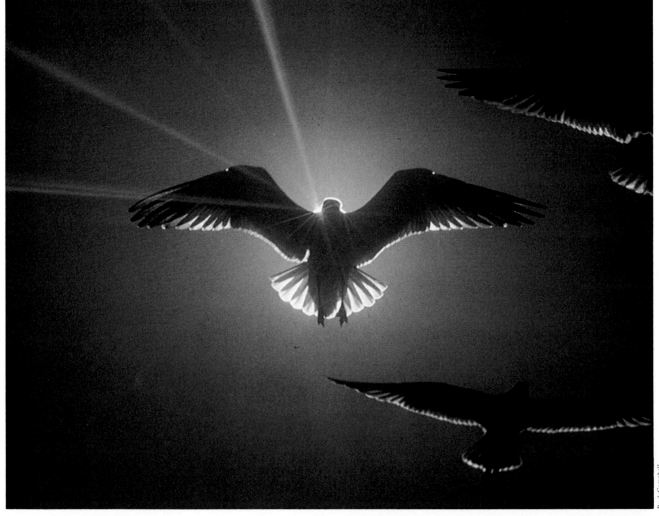

Buck Campbell

DEFTNESS COUNTS

A multiple-image filter turns one sunset into five. A star filter floats myriads of tiny stars across sun-spangled water or produces brilliant starbursts from any bright light. A motion filter seemingly propels that old rusty car into racing form. A diffusion filter adds a touch of romanticism to portraits. A fog filter lends mistiness to an otherwise dry day.

Alone or in combination, these filters challenge your imagination and skill. Used thoughtlessly, the result is hokey. Used imaginatively, breathtaking. They do things you've probably never seen, and you'll find that the pleasure of using them equals the pleasure of viewing the results. A number of these filters can be homemade as you'll see in the following chapter, "Making Your Own Filters."

The brightness of the light source determines the size of the star.

A star filter either has a cross hatch pattern etched on the glass or has a cross screen sandwiched between the glass.

STAR FILTERS

Star filters turn point sources of light and specular highlights into stars. A soft jewel-like sparkle often seems to emanate from pictures taken with a star filter. The number of points on the stars depends on the filter construction. Two- to sixteen-pointed stars are typical. The stars are produced by a thin crosshatch pattern that is either embossed or etched into the surface of the filter. Some filters also sandwich a small cross screen

between glass. The cross-hatchings refract the bright light. The grid pattern typically varies from 1 mm to 4 mm. The smaller grid patterns produce lots of stars and some diffusion. The larger grid patterns usually produce stars only from the brighter sources and only a very slight amount of diffusion. The angle of the stars can be varied by rotating the filter.

To see the effect and the angles of the stars, attach the filter to your lens

and after setting the aperture, stop down the depth-of-field preview button. You might notice that the stars sometimes nearly disappear with small *f*-stops. Usually a medium aperture around *f*/5.6 works best. Always check with the depth-of-field preview button to see the stars made with the aperture in use. The brighter and smaller the light source and the darker the background, the more spectacular the effect. Although the stars are quite pronounced when used with small, bright light sources, they can be used subtly and effectively with highlights. In sun-reflecting water they are almost unnoticeable, but the water seems to glimmer extra brightly.

By fastening a small piece of Mylar, mirror, or smooth foil material to an object you can add a star any place you want. When struck by bright light and viewed from the correct angle, the Mylar material or mirror will give off a bright reflection that the filter turns into a star.

Although numerous varieties of star filters are commercially available, you can easily make your own with a piece of window screen as you'll see in the next chapter.

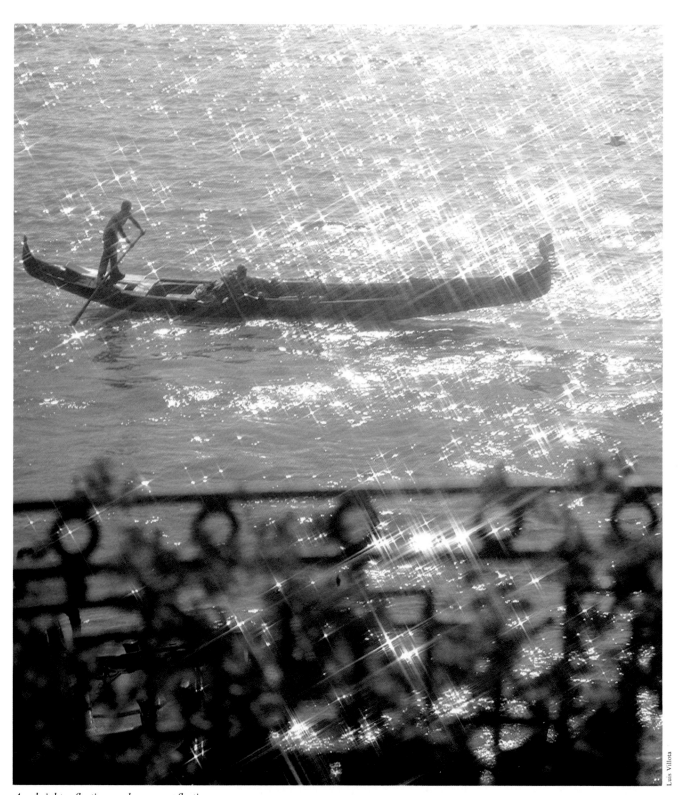

Luis Villota

Any bright reflection, such as sun-reflecting water, will provide enough brilliant light to form stars.

MULTIPLE-IMAGE FILTERS

Try using a multiple-image filter to put a little spice in your slide show or wall display. Depending on the design of the lens, a multiple-image filter can produce identical images in several different patterns. The different multifaceted lens surfaces produce images in concentric, radial, and linear patterns. They transmit nearly 100 percent of the light so no exposure compensation is required. Be careful when using them with wide-angle lenses. The border of the picture may be darkened by vignetting.

With a single-lens reflex camera, you can see the multiple-image effect in your viewfinder. Rotate the multiple-image filter until the composition pleases you. A simple subject with a simple background takes on a wonderland quality. A busy scene shatters into a wild, nervous collage. By cutting and fitting different colored gels to each of the lens facets a multicolored, multi-image reverberates within the photograph. Fasten the gels to the rim of the filter with slices of transparent tape.

John Fish

When used with subjects that normally occur in multiples like a clump of flowers, the use of a multi-image filter might not be noticed.

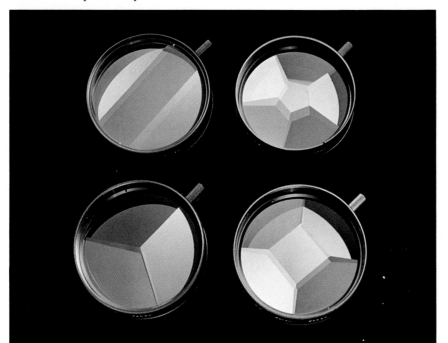

Different multiple-image filters are available to produce three to six images in concentric, parallel, and triangular arrangements.

73

© 1981 Bill Carter

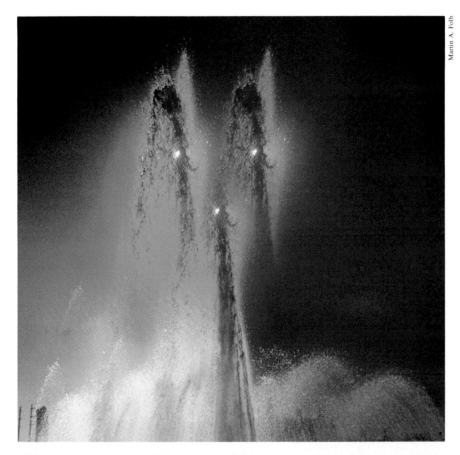

Martin A. Folb

By fastening a different colored filter gel to each facet of a 3-facet multiple-image filter, you can produce a different color for each image. Commercial multicolored, multiple-image filters are also available.

A multiple-image filter can produce a fairytale shot of legendary lands in the sky like in the photograph below and in the photograph on the opposite page.

Ken Biggs

DIFFRACTION FILTERS

A diffraction filter is a piece of plastic or glass with thousands of tiny ridges precisely spaced on its surface. When light strikes these ridges it diffracts or fringes into bands of color. Depending on the pattern of the ridges, the colors can be in a streak, a starburst, a circle, or multiple streaks. The intensity of the colors varies with the intensity of the light source. You can see the effect by simply looking through the filter, whether attached to an SLR camera or handheld.

The diffraction filter is usually held in an outer ring that can be rotated on top of an inner ring fastened to the lens. This lets you change the angles of the streaks within the picture. The colors show up best against a dark background. Against a light background, such as the sky, they appear somewhat washed out. You might want to position yourself until you find a dark background or compose the picture so that the light source is peeking out from behind something such as a tree or building. The tree or building acts as a dark background for the color pattern. Another alternative is to underexpose by 2 stops so that even the sky is darkened. Or you can use a dark filter with the diffraction filter to highlight the colors.

A diffraction filter fractures light into its component colors.

By underexposing this shot by 2 stops, the photographer strengthened the colors produced by the diffraction filter.

Dan Malczewski

The mark of a diffraction filter is unmistakable. Its rainbow colors easily become the center of attention, and they may not be worthy of it. Deftly used, the colors seem appropriate. Ineptly used, the colors cry out like a screaming baby in a library. The success of a diffraction filter depends largely on choosing an appropriate subject.

A diffraction filter absorbs little light; therefore no exposure increase is needed. It also shows little distortion in the remainder of the scene, so the final image is sharp.

A dark-colored filter, **right,** *was used to darken the sky to make the rainbow of colors from the diffraction filter stand out.*

A storm of color, **below,** *pours from the sky in this shot made with a diffraction filter.*

Fred Snyder

Allan Horvath

No diffusion filter

No. 1 diffusion filter

No. 2 diffusion filter

In portraiture, a diffusion filter minimizes skin blemishes and softens wrinkles. Diffusion filters are available in varying degrees of diffusion.

DIFFUSION FILTERS

Diffusion filters soften images in pictures. Enchanting, ethereal, and dreamy are the words that describe their effects when used traditionally. Renderings of romanticism that include brides, mothers, lovers, flowers, and idyllic pastoral scenes like summer picnics beneath willows drooping over a burbling creek have long felt the caress of the diffusion filter. You might say it's been used mostly to produce sentimentality in an effort to pluck a few chords of the heart. Surprisingly, these chords must be tireless as pictures taken with a diffusion filter seem to charm viewers time after time. Whether the charm results from the universal appeal of the subjects—moms, kids, and sweethearts—or from the dreamlike softness it imparts to a scene is uncertain.

The muted colors and misty atmosphere characteristic of a diffusion filter lend a romantic mood to this picture.

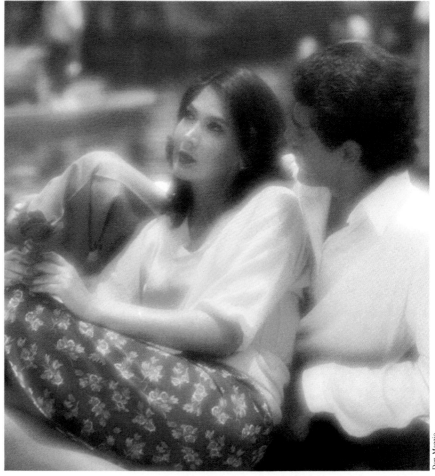

Don Maggio

Patrick Walmsley

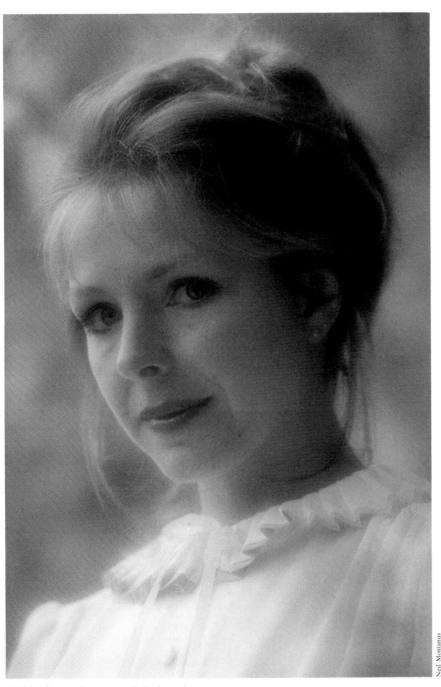

By blending and scattering light from the highlights a diffusion filter lowers the contrast and produces a more pleasing image.

Many portrait photographers consider a diffusion filter a necessity. In real life when talking to somebody we are seldom so rude as to closely inspect the face before us. Few of us really know or care to know of the details that make up a face. But in sharp portrait photographs such details are distressingly unavoidable. We see the wrinkles, pores, and skin blemishes and are uncomfortable, probably realizing our own faces look similar.

A diffusion filter diminishes the wrinkles, pores, and skin blemishes. Individual hairs flow into a curtainy sheen of color befitting a model. Traditionally the diffusion filter has been used more for portraits of women than men. In men, wrinkles and whiskers convey a certain toughness and virility. Whether used for men or women, a diffusion filter flatters the face.

There's more to diffusion filters than romantic renderings of wrinkles or blemishes. Any time you want to soften the image or obscure detail, it is effective. In softening detail you often give greater emphasis to colors.

As you'll see in the "Making Your Own Filters" section, diffusion filters are easily made at home with such materials as transparent tape, clear glue or cellophane. Commercial diffusion filters usually have an embossed pattern or small transparent particles scattered within the glass. Light refracted by the particles or embossed pattern softens the image. Yet the picture keeps a semblance of sharpness because clear areas of the filter pass light unhampered. The result is a blending of sharp and soft images.

79

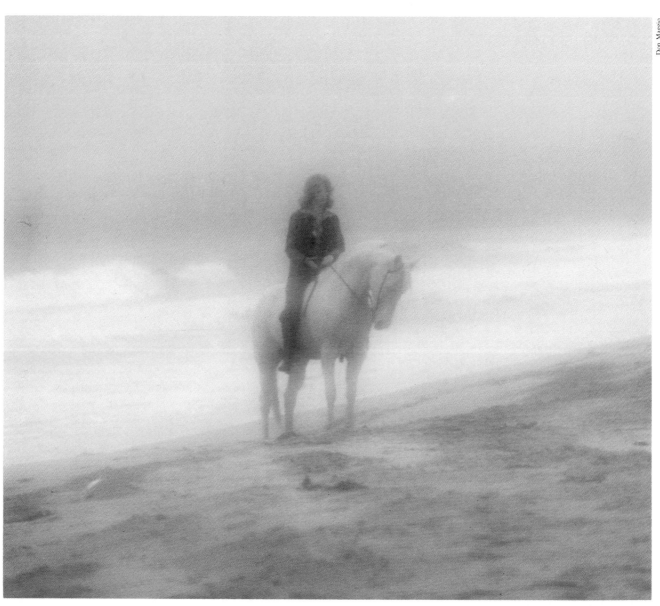

Don Maggio

FOG FILTERS

A type of diffusion filter called a fog filter is often used with landscapes. Fog filters are commonly available in degrees of fog ranging from a light mist to a heavy fog. To keep detail, make the image as large as possible. To obscure detail, make the image small. Both fog and diffusion filters can be used singly or in combination. The aperture you use can affect a fog filter. A large aperture enhances the softness, and a small aperture minimizes the softness.

Backlighting can be used to complement a fog or a diffusion filter because it too carries a dreamlike quality. The fog or diffusion filter spreads some of the bright highlights into darker areas lowering the contrast. A luminous glow often shines from a backlighted diffused picture. The scattering of the light may cause your meter to indicate settings that result in underexposure. The tendency should be to give 1/2 stop more exposure than that recommended by the meter and to bracket when in

A fog filter is simply a denser version of a diffusion filter. It quite effectively lives up to its name and adds fog to a scene.

doubt. The additional luminosity caused by slight overexposure often works to your advantage when using a fog or diffusion filter.

CENTER-CLEAR FILTERS

In addition to the standard diffusion filter, there's also a center-clear diffusion filter. It might be thought of as a doughnut. The center portion is clear, and the outer ring is diffuse and sometimes colored. With the diffuse ring blocking detail, emphasis shifts to the sharp center area. Distracting backgrounds are readily suppressed with this filter. The contrast between the sharp and unsharp areas gives an added feel of dimension. When a single large image, such as a face, fills the center, the image seems to leap out. With a smaller image, dimensionality remains apparent but not quite so obvious.

A center-clear filter suppresses the background and focuses attention on the subject.

Neil Montanus

81

MOTION FILTERS

Motion filters hurtle stationary objects into high-speed. Or so it seems. They work by blurring half the picture with speed lines while retaining a complete and sharp image in the other half. The results resemble photographs in which a moving subject was panned with the camera (camera moved to follow subject during exposure). With a little imagination, you can turn skyscrapers into rockets, apples into cannonballs, nags into thoroughbreds. This filter works best with a simple subject against a simple background. Cluttered scenes obscure the speed lines which impart the feeling of motion.

The half of the filter that produces the blur is cylindrical. The other half has a normal configuration. These attachments work best with lenses of normal focal length (50–55 mm).

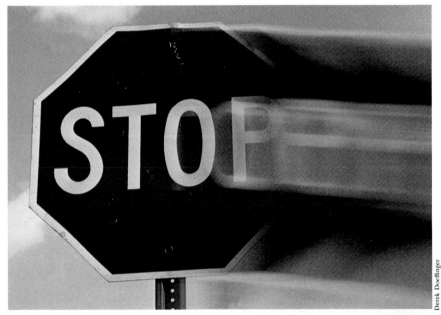

Derek Doeffinger

By streaking half of a subject, a motion filter seems to hurtle even obviously immobile subjects into motion.

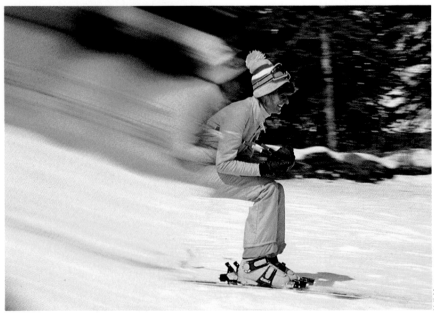

Neil Montanus

Simple subjects with plain backgrounds often work best with a motion filter.

OTHER SPECIAL EFFECTS FILTERS

We have shown you the most commonly used special-effects filters, but there are others. Some of them, if not downright bizarre, are then a bit unusual. There are filters that add "rain" or a rainbow to your pictures, concentric circles and swirls, and one, a zoom filter, that simulates the zooming effect achieved by changing focal lengths on a zoom lens during the exposure.

Variations on many of these filters are also available, and new ones with fresh effects show up regularly. For instance, instead of giving a zoom effect, one filter surrounds the subject with a whirlpool. These filters can also be used in combination with colored filters, further dramatizing the special effects. But like all special-effects filters, how "special" the effect is depends more on your abilities in making the picture than on the filter.

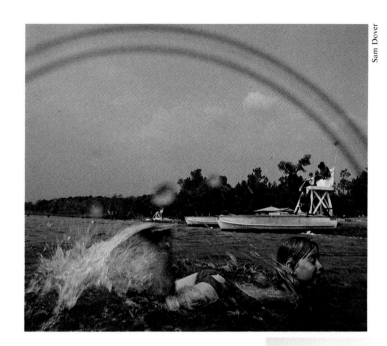

Sam Dover

When you place a rainbow filter in front of your lens, you actually photograph the rainbow on the filter as you photograph the scene. This requires extreme depth of field so use a wide-angle lens set at a small aperture, preferably f/16 or smaller. This photo was taken on KODAK EKTACHROME 100 Film with a 24 mm wide-angle lens set at f/22.

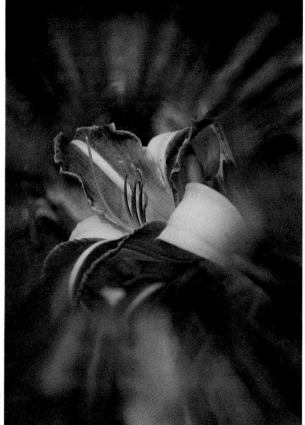

Sam Dover

The lines etched into these zoom, whirlpool, and swirl filters create the patterns in the photos. Each has a clear center in which the subject is to be placed. This picture was taken with a zoom filter.

Making your own filters

You can easily make several special-effects filters that work nearly as well as anything commercially available. You can also make your own color filters, but these can't match the quality of commercially made filters. Commercially produced color filters are made from optical grade glass, gelatin, and plastic. The materials available to you for color filters are not of such a high grade, though you may find them perfectly acceptable or even desirable.

Derek Doeffinger

HOMEMADE COLORED FILTERS

To produce a colored filter you need a transparent material that is already colored or can be colored. Colored cellophane is a simple solution. So is theatrical gel. Perhaps you might like to try coloring your own filter by applying a felt-tipped pen to a sheet of clear acetate (available from art-supply stores). Afterwards hold the sheet in front of the camera as you take your pictures. These acetate filters are better at producing pastels than deep colors. To highlight the pastel shades, choose light-colored subjects against a bright background. Increase exposure by 1/2 to 1 stop if you want to further lighten the colors.

One easy way to make a colored filter is to color a piece of acetate with a felt-tipped pen. This technique was used to make a red-blue filter used to photograph the horse above.

ADAPTERS

In making your own filters you may or may not want the convenience of an adapter ring into which you can fit your filter material. If you're only

experimenting, you'll find it just as easy to hold the homemade filter in front of the lens. For constant use, however, an adapter ring is a great convenience.

HOMEMADE DIFFUSION FILTERS

The variety of items suitable for homemade diffusion filters might seem more fitting for a scavenger list: stockings, crumpled cellophane, clear nail polish, petroleum jelly, transparent tape. Anything transparent that scatters some of the transmitted light should work as a diffusion filter.

*A thin coating of petroleum jelly smeared on a skylight filter gives an effective diffusion, **right**. For more diffusion apply a thicker coating.*

This Parisian flower stall becomes as romantic as a daydream when photographed through an X of transparent tape fastened to a filter.

Derek Doeffinger

MAKING DIFFUSION FILTERS
STOCKINGS

Stockings are probably the easiest to use. Simply stretch a piece of fine-meshed nylon stocking over the lens, and fasten it with a rubber band. Unless you want the color of the stocking to tint your pictures, choose a neutral colored stocking such as gray or beige. White stockings can also be used. They scatter much light, greatly reducing contrast.

CELLOPHANE

By crumpling up a piece of cellophane and then smoothing it out, you can create another inexpensive diffuser. Fasten the cellophane to the lens with a rubber band.

PETROLEUM JELLY

Petroleum jelly offers a slightly messy, although effective, way of diffusing incoming light. To a clear glass filter (skylight) or a clear piece of glass, apply a thin coat of petroleum jelly. Smear it on with your hand or brush it on in straight lines. The lines refract the light and produce an interesting pattern. The thickness of the layer of petroleum jelly controls the amount of diffusion. By looking through the vaseline-smeared filter you can easily judge the effect it is producing. Be sure that the petroleum jelly is on the outside when you fasten or hold this device over your lens, otherwise you might find yourself with a messy lens-cleaning job.

Bob Rapelye, Rochester
Institute of Technology

NAIL POLISH

Clear nail polish works similarly to petroleum jelly but without quite the mess. Simply brush it on an old sky-light filter or a piece of glass. When dried, it's ready to use. You might want to experiment by designing different patterns on the glass or by stippling the nail polish onto different areas. Use nail polish remover to clean up.

TRANSPARENT TAPE

To a glass skylight or UV filter, fasten a crisscross of tape. You gain some control

over the amount of diffusion by varying the width of tape. However, you'll have to shoot a roll of test film to determine how tape width affects diffusion.

HOMEMADE SPLIT-FIELD FILTERS

With gelatin filter squares you can conveniently change or add color to only a part of the scene. You can make the top part of a scene blue and the bottom normal. Or you can make the bottom magenta while the top is green. The combinations are endless. To darken the sky, place a gelatin or plastic neutral density filter over the lens and align it with the horizon. Set the exposure before you attach the filter. If you don't, the filter can cause the meter to give normal exposure to the sky.

In this picture, two gelatin filters with similar filter factors were used so the picture would receive nearly uniform exposure.

You can hand color a split-field filter with acetate and felt-tip markers.

MAKING A TWO-COLOR SPLIT-FIELD FILTER

All you have to do is cut two differently colored gels and butt them together. Avoid taping across the full border where they meet. The tape may show up as a faint swath in the picture. Try taping them at the top and bottom, edges, and holding them over the lens when you take a picture. For a sturdier split-field filter try this:

Cut a circular hole slightly wider than your lens out of a piece of black cardboard. Tape the filters to it around the perimeter of the circle.

The closer to the lens you place the filters and the larger the aperture you use, the softer will be the blend between one filter edge and the other in the picture. Choose color filters with similar filter factors so the density is the same throughout the picture.

HOMEMADE STAR FILTERS

To obtain the star effect without a commercially made filter you need only to visit your local hardware store for a piece of window screen. Cut a piece large enough to cover your lens. You can simply hold it in front of the lens during exposure. However, if the exposure is longer than 1/30 second, slight movement of the window screen as you hold it might blur the stars. For sharp stars during long exposures, mount the window screen into an adapter ring that fits your lens.

Derek Doeffinger

This picture was taken with a small piece of window screen held in front of the lens.

To take starburst pictures with a window screen at exposures longer than 1/30 second you should mount the window screen in an adapter and fasten it to your camera.

HOMEMADE CENTER-CLEAR FILTERS

Center-clear filters are colored or diffusion filters with a clear center. They give an effect much like a vignette, with the subject in the center standing out and the rest of the picture fading into the background. Matte acetate can be used for both the clear and colored center-clear filters. Cut a hole the size of a dime in the center of the sheet. Then hold the sheet in front of your lens. This technique works particularly well with telephoto lenses. Normal and wide-angle lenses tend to show the hole in the acetate as a noticeable edge. You can soften the edge somewhat by placing the acetate sheet as close to the lens as possible and by using a large aperture. If the light is too bright to permit use of a large aperture, you can sandwich in a neutral density filter in the gelatin filter frame.

For a center-clear colored filter, cut a hole in colored cellophane or in a gelatin filter.

To make your own center-clear filter you need only cut a hole in matte acetate, colored cellophane, or a gelatin filter. A red homemade center-clear filter was used for the picture of the tulip. Notice how the filter directs attention to the tulip by suppressing the background.

Derek Doeffinger

THE HARRIS SHUTTER

The Harris Shutter is a cardboard strip with three filter windows along its length. In one window is a green filter, in another a red filter, and in the last a blue filter. Mounted in a slotted holder, the filter strip is dropped past the lens to make an exposure. With the Harris Shutter you can splash swirls of red, green, and blue on to race cars, sprinters, and other moving subjects. Like the multiple exposure technique discussed on page 62, the Harris Shutter gives exposure through red, green, and blue filters separately. Unlike the multiple exposure techniques, the Harris Shutter works in a fraction of a second. The exposure lasts as long as it takes for the three cardboard mounted filters to drop past the lens (usually around 1/30 second). You can pan and zoom the camera when using a Harris Shutter if you mount the camera on a tripod.

To use the tricolor filter technique on a fast-moving subject like this horse and rider you need a Harris Shutter.

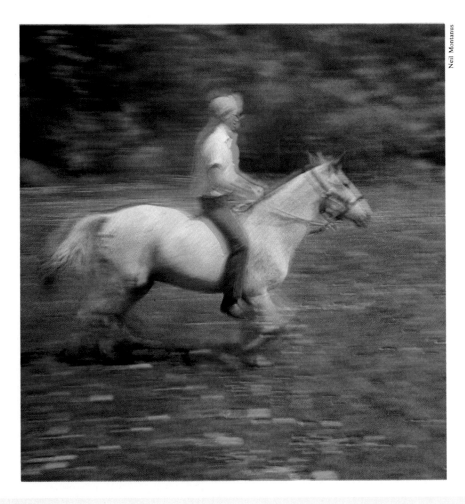

Neil Montanus

MAKING A HARRIS SHUTTER

You need a No. 25 red filter, a No. 38A blue filter, and a No. 61 green filter. Gelatin filter squares are cheaper but plastic filters are acceptable (KODAK WRATTEN Filters are available from photo dealers in 50, 75, and 100 mm gelatin squares). Be sure to choose filters large enough to cover the camera lens. Use black cardboard for construction. The diagrams show how to make the shutter assembly. The model shown here was attached using an adapter ring, filter holder, and lens shade from a square filter system. You could also use a retaining ring and an adapter as fasteners. No dimensions are given, as they will vary according to the size of the filters used.

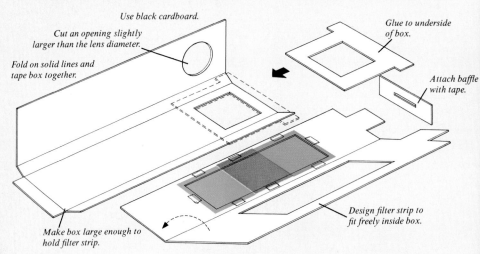

Use black cardboard.

Cut an opening slightly larger than the lens diameter.

Fold on solid lines and tape box together.

Glue to underside of box.

Attach baffle with tape.

Design filter strip to fit freely inside box.

Make box large enough to hold filter strip.

To make the exposure with the Harris Shutter, set your camera shutter on the T or B setting. Hold the lower blank of the filter strip in front of the lens, and open the camera shutter. At the appropriate moment, drop the filter strip into the box. The upper blank of this strip stops the exposure by blocking the lens. Close the camera shutter, advance the film, and you are ready for

COLOR SLIDES FROM BLACK-AND-WHITE PRINTS

Unknowingly you may be hoarding a cache of negotiable black-and-white treasure. If you are, it can easily be converted into color currency. I'm referring to that forgotten stack of black-and-white prints. The one behind the magazines on the bookshelf. That stack represents some of your best black-and-white work. You can make it equally good in color. Simply copy some of those prints through a color filter onto color slide film. The results will surprise you. Dark-colored filters generally give the best results. Choose photographs that have silhouettes or scenes that seem appropriate with colored filters. Photographs of your grown-up children as youngsters look fine when copied through a sepia filter. Brilliant beach scenes easily transform into night scenes when copied underexposed through a No. 47 blue filter.

To turn a black-and-white print into a colorful slide, use a color filter and copy the print onto slide film.

Jacob Warner

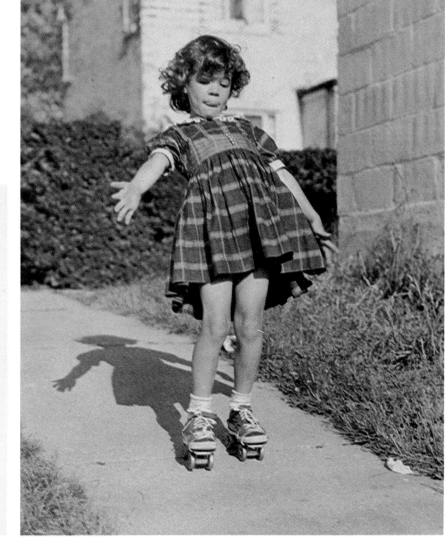

Filter strip

the next picture. Since different "shutters" will drop at different speeds, you may have to determine the best lens opening by trial and error.

Filters for infrared films

So accustomed, so trusting are we with sight that we seldom question that things could appear other than how we see them. The world woven by our sight consists of but a few threads that comprise a long ribbon called the electromagnetic spectrum. How would things look if instead of light we perceived x-rays, radio waves, ultraviolet radiation, infrared radiation, or any other energy making up the electromagnetic spectrum? To x-ray perceiving eyes, would a fleshy caterpillar be invisible? Would a tree be reduced to a network of pith? Although imaging x-rays is beyond ordinary photographic equipment, imaging infrared radiation is not. And the sight is one to behold.

Tom Hurtgen

BLACK-AND-WHITE INFRARED FILM

KODAK High Speed Infrared Film exposed through a No. 25 red or No. 29 deep red filter, will produce haunting landscape photographs. Trees and grass turn ghostly white, skies darken dramatically, and clouds lighten by contrast. Since deciduous trees reflect much infrared radiation, they turn white. The blue sky as well as conifers reflect little infrared light, so they darken. By adding a polarizing filter to one of the red filters, you can so darken the sky that a nighttime effect results. A red filter and infrared film also cuts through aerial haze to produce sharp landscapes. Produced by the scattering of blue light, haze in the picture is eliminated when the blue light is blocked by the red filter.

Since neither you nor the camera meter can measure infrared radiation, exposure requires some guessing. For daylight exposure of the black-and-white infrared film through one of the red filters, begin by setting the ISO (ASA) dial at 50. A typical exposure on a sunny day for a distant scene is 1/125 second, $f/11$, and for a nearby scene is 1/60 second, $f/8$. These exposures are only starting points. To obtain a good exposure, bracket 1 or even 2 stops under and over the original exposure. If you're taking pictures under tungsten light, use this same procedure but set the camera for ISO (ASA) 125.

The camera lens focuses infrared rays in a slightly different plane than light rays. Usually you can focus as normal. However, if you're trying to obtain absolute maximum depth of field such as in a landscape photograph, you should make a focus adjustment. This adjustment is fairly simple since most lenses have a focusing mark for the infrared focusing. This mark is usually colored red and

A No. 25 red or a No. 29 deep red filter is most often used for black-and-white infrared photography. Each filter blocks much of the light yet transmits infrared radiation.

is next to the normal focusing mark. To use it, first focus normally. When you have the lens focused to provide maximum depth of field, note the distance corresponding to the normal focusing mark. Now shift that distance so it corresponds to the infrared focusing mark. If your lens doesn't have an infrared focusing mark, focus on the near side of the subject.

KODAK High Speed Infrared Film should be loaded, unloaded, and processed in complete darkness. Although the film magazine is light-tight, it is not infrared tight. Loading and unloading it in light often fogs the film.

To lessen the risk of losing sensitivity or increasing fog, keep unexposed infrared films in the refrigerator or freezer. When removed from the refrigerator allow a warm-up time of 1 hour and when removed from the freezer allow a 1½ hour warm-up time before removing 35 mm magazines from the package. Allow sheet films an extra hour of warm-up time.

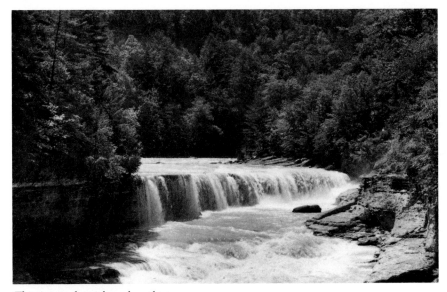

The picture above shows how the scene looks on KODAK PLUS-X Pan Film. The water isn't blurred because a faster shutter speed was used.

The picture on the opposite page was taken with KODAK High Speed Infrared Film and a No. 25 red filter. Deciduous trees turn ghost white. Still water normally blackens. Full of air bubbles, rushing water remains unaffected, although the slow shutter speed blurs it.

COLOR INFRARED FILM

Originally designed for camouflage detection and now primarily used for scientific purposes, color infrared film works equally well for creative color effects. Some parts of the scene will be colored normally while others drastically change colors. For instance, shot through a No. 15 deep yellow filter, a blue sky remains blue while green trees turn a brilliant magenta. The colors obtained depend in part upon the filter used and the infrared reflectance of the various subjects.

Original scene

Infrared film—no filter

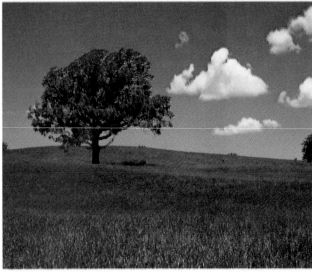

No. 15 deep yellow filter

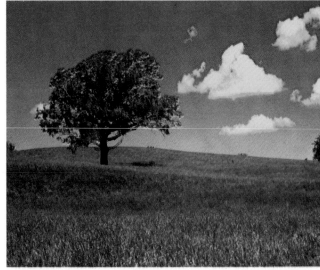

No. 25 red filter

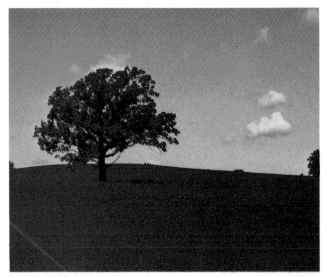

No. 38A blue filter

No. 58 green filter

Derek Doeffinger

94

Conventional color films have three dye layers sensitized to blue, green, and red. KODAK EKTACHROME Infrared Film also has three dye layers but they are sensitized to green, red, and infrared. The blue-sensitive layer is omitted. In the processed slide, the green-sensitive layer yields a yellow image, the red-sensitive layer gives a magenta image, and the infrared-sensitive layer produces a cyan image. However, since all three layers are affected by blue light, various blue-blocking filters are required. The amount of blue light blocked as well as other colors of light blocked, changes the colors rendered.

A KODAK WRATTEN Gelatin Filter No. 15 (deep yellow) is most commonly used with color infrared film for special effects. However, you can also use red, green and even blue filters for varying color results. For instance, a red filter turns blue skies green and green foliage orange.

Since normal light in addition to infrared radiation produces the image, you can focus as usual. However, load the film into the camera in subdued lighting to avoid fogging. As with black-and-white infrared film, exposure is somewhat trial-and-error. For daylight exposure set your camera for ISO (ASA) 100 and attach a No. 15 deep yellow filter to your lens. A typical exposure on a sunny day is 1/125 second at $f/16$. As with black-and-white infrared film exposures, bracket one stop over and one stop under the recommended exposure. You can also use electronic flash indoors. Again, bracket until experience proves the exposure needed with your equipment.

Before use, store EKTACHROME Infrared Film in the freezer in the original sealed package. Warm-up time is 1 to 1½ hours after removal. Have it processed soon after exposing the film to avoid emulsion changes affecting color balance.

Recommended reading

If you use filters for creative purposes, then you might like to learn more creative techniques covered in some of the books listed below. If you use filters for technical purposes, then you'll probably be interested in the books on the technical uses of filters. Whatever your reason for photography, there's a Kodak publication to help you out.

Applied Infrared Photography
(M-28) $6.00
This book explains the many scientific and technical uses of infrared photography from the examination of paintings to the detection of plant diseases. Methods, equipment, lighting, and numerous applications, including creative ones, are clearly presented. *84 pages*
ISBN 0-87985-009-4

The Joy of Photography
AC-75H (hardcover) $24.95
AC-75S (softcover) $14.50
A thorough guide for both the beginning and advanced photographer, this book covers the technical and creative aspects of photography. It carries you from camera handling into the darkroom, delves into photographic equipment, and explores the many ways of building a picture. Individual subjects such as landscapes, sports, nature, and people are also studied. *302 pages*
Hardcover: ISBN 0-201-03916-8
Softcover: ISBN 0-201-03915-X

KODAK Filters for Scientific and Technical Uses
(B-3) $9.95
Aimed at scientists and laboratory technicians who need spectrophotometric data for filters, it's nonetheless good reading for anyone who wants to know more about filters. You'll find information about the various types of filters, their physical, optical, and transmission characteristics as well as their photographic uses. *92 pages*
ISBN 0-87985-282-8

Ask your photo dealer for these publications. If he cannot supply them, you can order by title and code number directly from Eastman Kodak Company, Department 454, Rochester, New York 14650. Please enclose payment with your order, including $1.00 for handling plus applicable state and local sales taxes.

KODAK Guide to 35 mm Photography
AC-95S (softcover) $9.95
Loaded with photographs, this book will familiarize you with camera handling, Kodak films, exposure, flash, equipment, composition, and more. The pictures show you where it's at. The text shows you how to get there. *285 pages*
Softcover: ISBN 0-87985-236-4

More Joy of Photography
AC-70H (hardcover) $24.95
AC-70S (softcover) $14.50
This is the book for the photographer who likes creative techniques. The first two chapters tell you how to develop your own personal creative style and how to use camera controls creatively. A third chapter explodes with 100 creative techniques covering topics like painting with flash, hand-coloring photographs, using time lapse, and photographing mirror reflections. *288 pages*
Hardcover: ISBN 0-201-04544-3
Softcover: ISBN 0-201-04543-5

Index